Perfect Imperfection

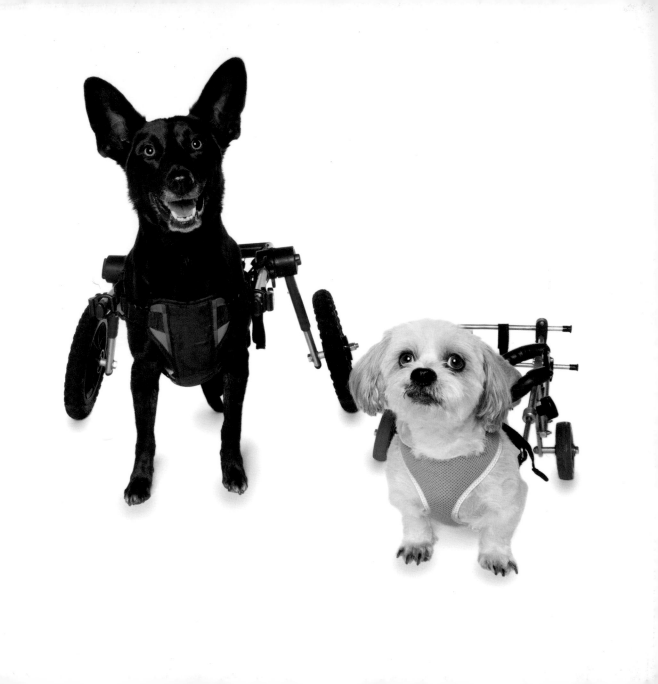

Perfect Imperfection

Dog portraits of resilience and love

Alex Cearns

ABC
Books

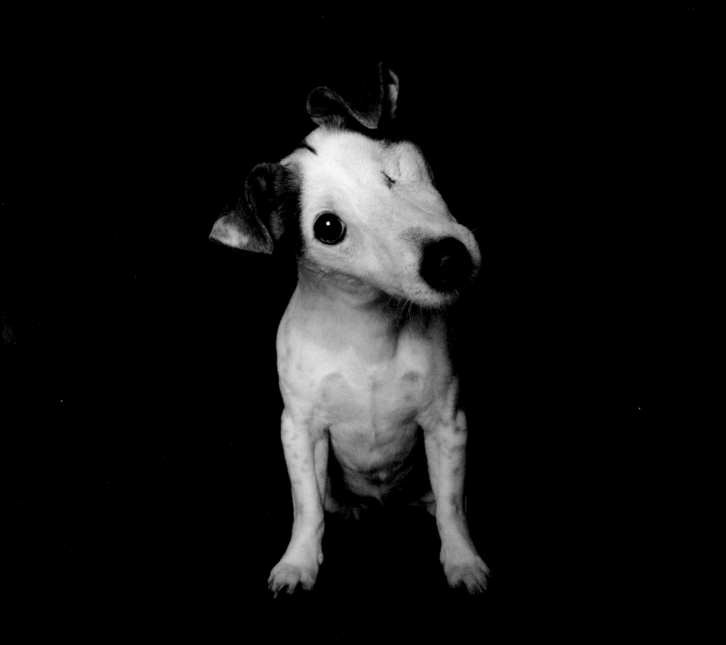

To Debora

Introduction

Dogs by nature are happy animals and every day our own dogs help us to appreciate the simple things in life. Dogs are our closest companions and greatest teachers. They make the most out of their time with us and from them we can learn so much about seeing the bright side of things and about never giving up.

At some stage in our lives, most of us have experienced insecurity about our physical appearance. Yet beauty is nothing to do with window dressing – it comes from within. We need to learn to accept our own differences and those of others, to view the positive in every situation. Dogs are our role models with this, as their tenacity to overcome adversity is inspirational.

The dogs of *Perfect Imperfection* will uplift and inspire, finding a special place in your heart with their ability to overcome physical adversity. My goal was to capture and share their intrinsic beauty and spirit, their sweetness and strength. They do not recognise their limitations, nor do they dwell on their differences.

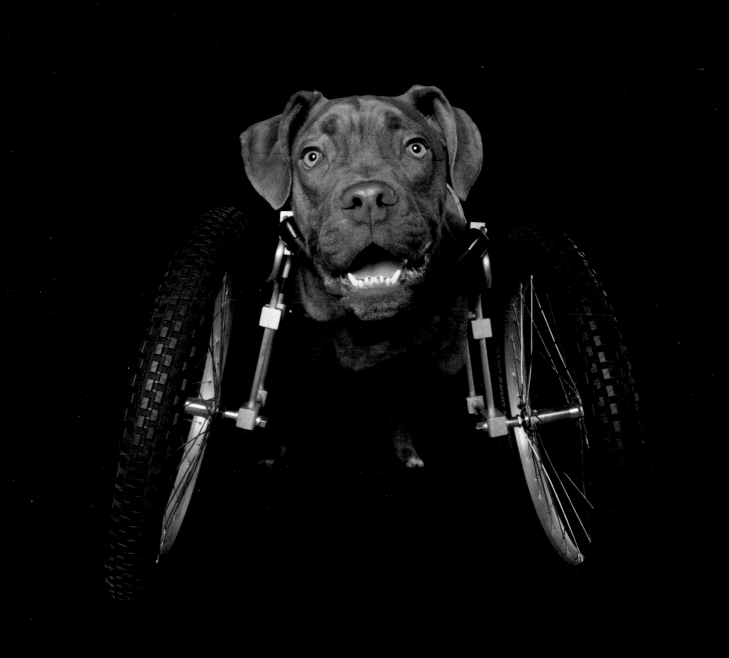

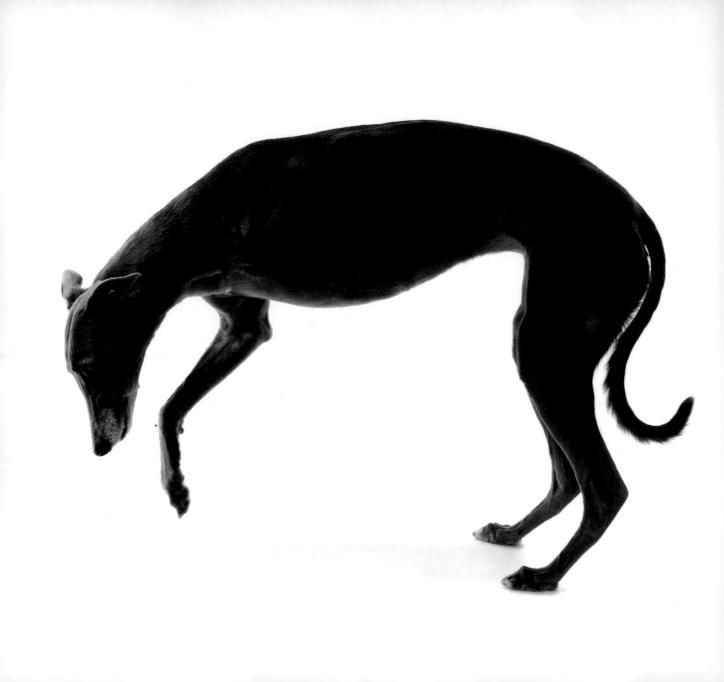

They adapt to their unique bodies without complaint and they survive with determination. They push on, always, wanting to be included and involved in everything as much as an able bodied pet does.

I love every dog I've had the privilege of photographing, but those perceived as 'different' hold a special place in my heart. These are the pooches who have lost a leg, have been born without eyes, or are still showing the scars of their pre-rescue life. These courageous canines are perfectly imperfect and they touch the hearts of all who know them.

Alex Cearns

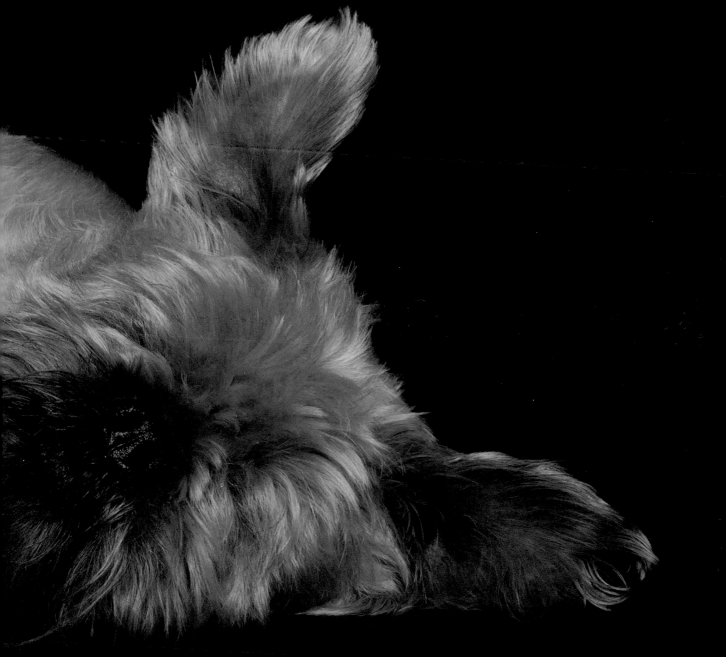

Raul

5 years old
French bulldog

Human:
Alice

In February 2016 Raul became sick one night. We didn't know what was wrong; he didn't want to eat or be around us.

The next morning, he was missing. Finally we found him beneath a trailer in the backyard. He was scared of me and we realised he was in a lot of pain. We took him to a vet and eventually a scan revealed a lower disc had ruptured into his spine. We went ahead with an operation, even though it was unlikely to be successful as too much time had passed.

Raul came out of his op like a trooper. As soon as he could, he was dragging himself around like a seal, not realising his handicap in the slightest, and above all happy to see us. We knew then that his quality of life would largely be unchanged. We researched the best wheelchair for him. Raul also has aqua-therapy, acupuncture and chiropractic work. At home he drags himself around quite happily – outside we use the wheelchair and he doesn't know the difference.

Raul is part of our family; Gavin and I have always been very attached to him and since his paralysis that's only increased. He makes us laugh all the time with his quirky personality. He certainly didn't win the genetic lottery – he's also allergic to everything and undergoes treatment for that – but he takes it all in his stride.

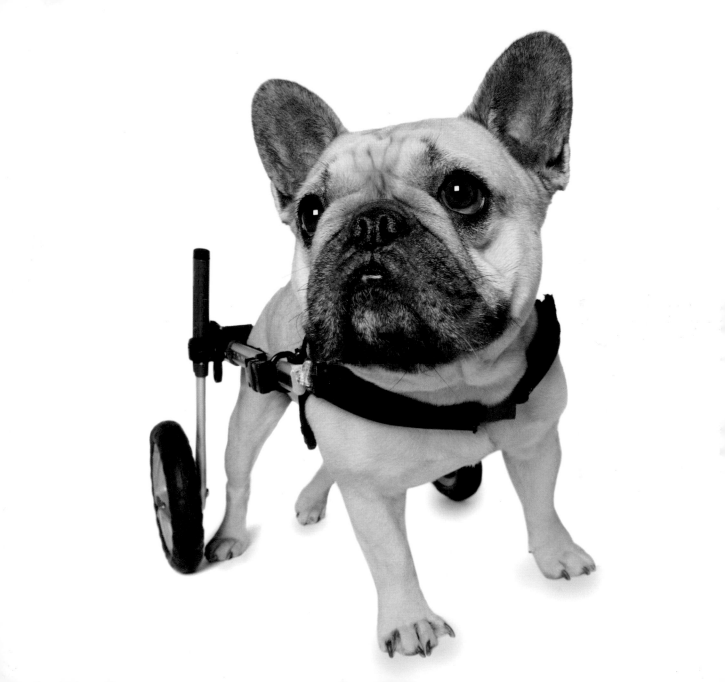

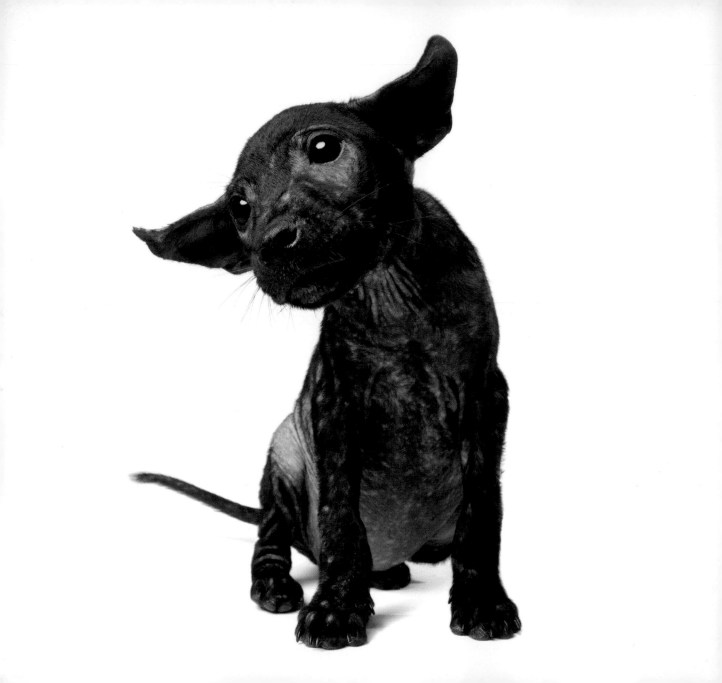

Bali Pip

8 weeks old
Small mixed breed

From:
Bali Animal
Welfare
Association

Alex writes: Bali Pip was rescued from the streets of Bali. She had mange at the time, so had lost most of her fur. When I flew to Bali to photograph rescue animals, I selected Pip for a photo session. A cute, inquisitive and playful pup, Pip was a natural and loved being in the spotlight – during her photo session she even learned how to do a high five! Her images went viral and people from all over the world fell in love with her. After her mange cleared up she was adopted into a loving home.

Moe

16 weeks old
American bulldog

Human:
Kate

Moe was surrendered to my vet clinic at 8 weeks old. He'd been bought online cheaply and had a sore leg. But the new owners couldn't afford treatment for it. He was also covered in fleas, had a bellyful of worms and was severely malnourished. My heart broke for him so I took him on to foster. X-rays showed fractures to his femur and pelvis that were at least three weeks old and looked as if he'd been kicked. Sadly, repairing the bone was impossible as the injuries had been left untreated for too long. Four weeks of physio didn't help so the decision was made to amputate.

Moe's the best little pup in the world. Even though he had a very tough start in life he never lets anything stop him or hold him back. He was up and walking just one hour post op. He's outgoing, friendly and cheeky – and he's my best friend.

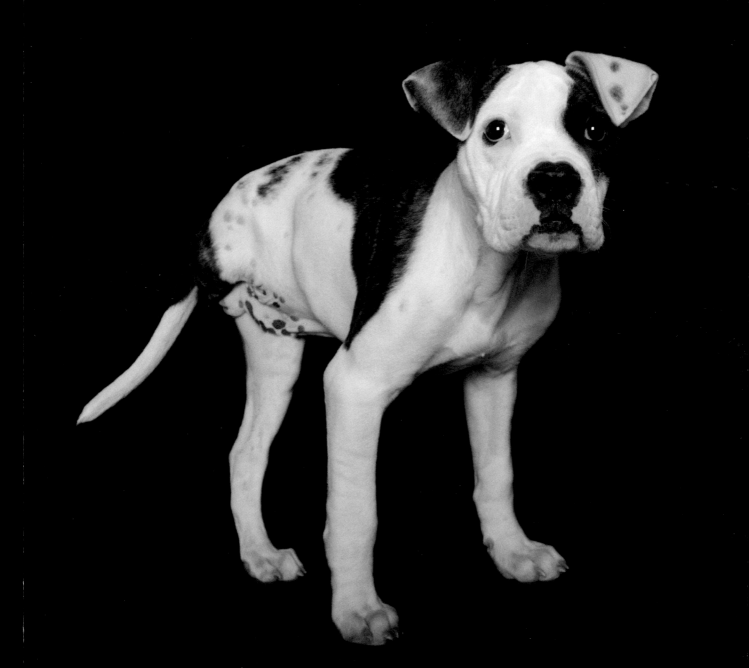

Jack

**3 years old
Pug**

**Human:
Tessa**

When Jack was just 6 weeks old he was bitten on the face by an exuberant older puppy. His right eye was punctured and had to be removed. The left eye was also damaged and he lost 80 per cent of his vision, which has deteriorated further over the years, with only 10 per cent left now. He sees things in shadows and he can't see in the dark very well so he won't move and gets a bit scared.

He was rejected by several families before we got the call from the breeder and my partner said to go check him out. We were after a puppy and not set on the breed but the thought of giving a home to a dog with special needs appealed.

I sent my partner a pic from the breeder's place and his reply was: 'Even disabled dogs need love. Bring him home; we can give him the life and the love he needs to thrive plus meet his health needs [I'm a nurse]. That dog will teach us more than we know.'

And wasn't he right! Jack loves surfing, stand-up board-riding and runs at the beach. He's helped teach the countless pug rescues that come to our home that life's great, and he's helped them transition. He's been the true teddy bear. He's never been disabled to us; he's just physically different.

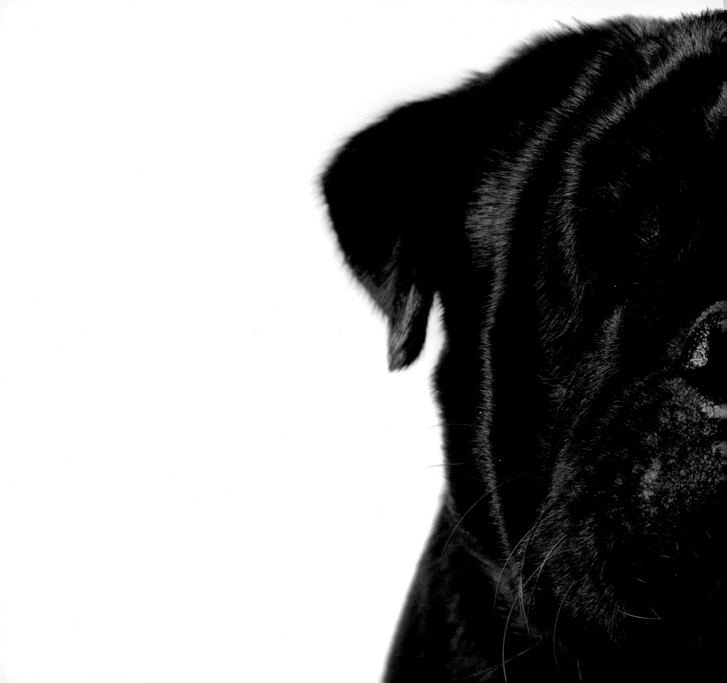

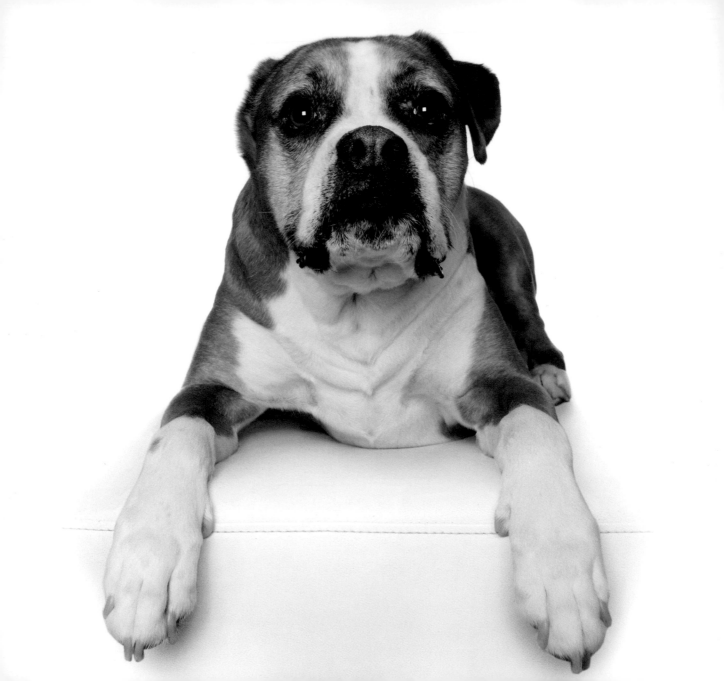

Cass

11 years old
Boxer

Human:
Elaine

We adore Cass. He's a massive part of the family. He's also quite a needy character and loves to be part of the action.

When he had his ear removed, he was glared at by another dog and ever since has been wary of other dogs. When his best mate died early this year we thought he was going to go as well as he was very depressed. But he has since become the best father figure for his new little puppy sister, Betty. We are amazed as we thought he would find the transition challenging, but instead he has been incredible with her.

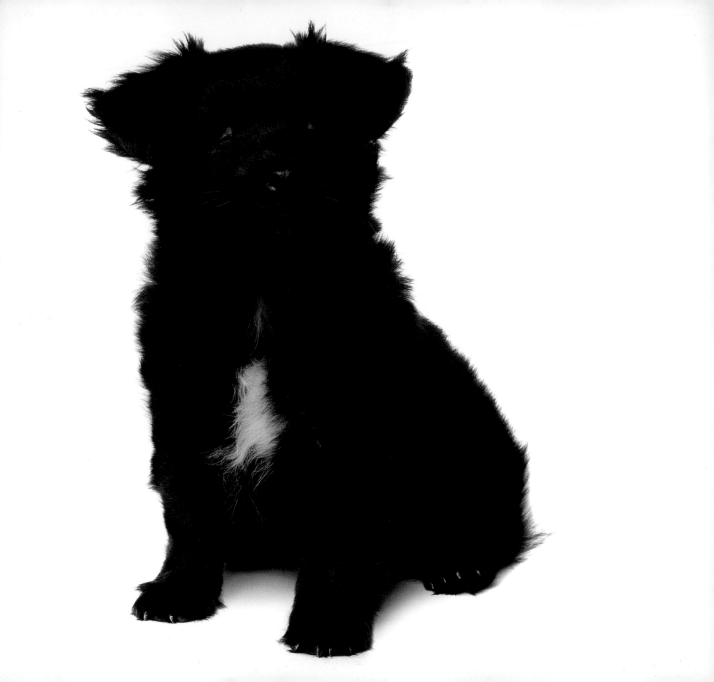

Ray

12 weeks old
Chihuahua x
Pomeranian

Human:
Sue of SAFE
Perth

Ray was born with malformed eyes and has been blind from birth. He was taken to a vet, who recommended euthanasia. The rescue organisation I founded, Saving Animals From Euthanasia (SAFE) Perth, was contacted and Ray came into my care as a foster dog. Within a few weeks we had fallen in love with him and adopted him.

Ray may be small but he has a huge personality. He lives with two big dogs and yet he is the guard dog of the house. His blindness is of no consequence to Ray – he races around the place and watching him, you wouldn't even know he can't see.

Ray has a special bond with my seven-year-old son. They're the best of friends. Ray brings lots of love and joy to our family and we give him the best life we can. He makes the most of everything and is a big dog in a small dog's body – with a huge heart.

Matilda

**14 years old
Bichon Frise**

**Human:
Lisa**

Matilda had her right eye removed because of glaucoma. She's coped extremely well until recently when the sight in her left eye deteriorated and her vision is now limited. Sadly, Matilda's had three seizures in the last six months, and she now has dementia, arthritis and minor incontinence. (But really, her health in general is pretty good for a princess of her age!) She does tend to get under our feet quite a bit and gets lost sometimes, even in the house.

Matilda means the world to us – she's our fourth child and the glue that keeps our family strong. She's laid back, easy going and very attentive to those around her. Maltilda is always waiting to welcome us all home at the end of the day.

One time when my parents were looking after Matilda, they returned from an evening out to discover she'd been very busy. Matilda had dragged Nan's basket from the pantry through into the lounge room and proceeded to empty it of its contents including sunglasses, vitamin bottles and a chequebook. (What girl doesn't like a chequebook, after all?) Since then, we've come home a few times after an evening out to find our belongings in Matilda's bed – shoes, jumpers. A hint, perhaps?

For such a little girl in stature, she has a huge heart and we can't imagine our lives without our princess. We love her to bits.

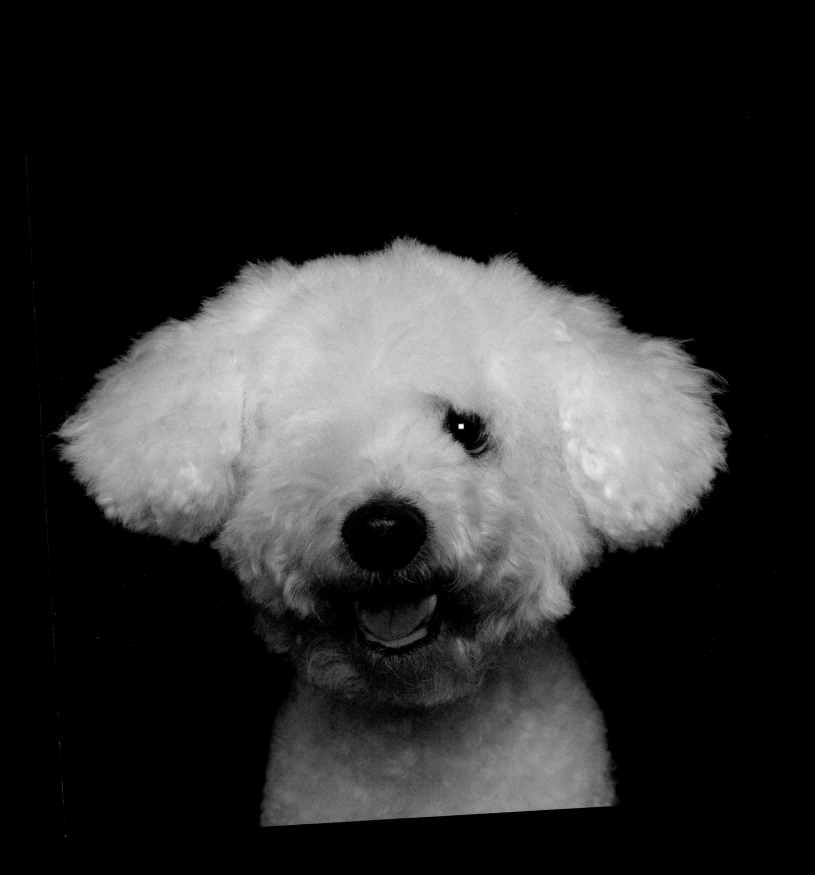

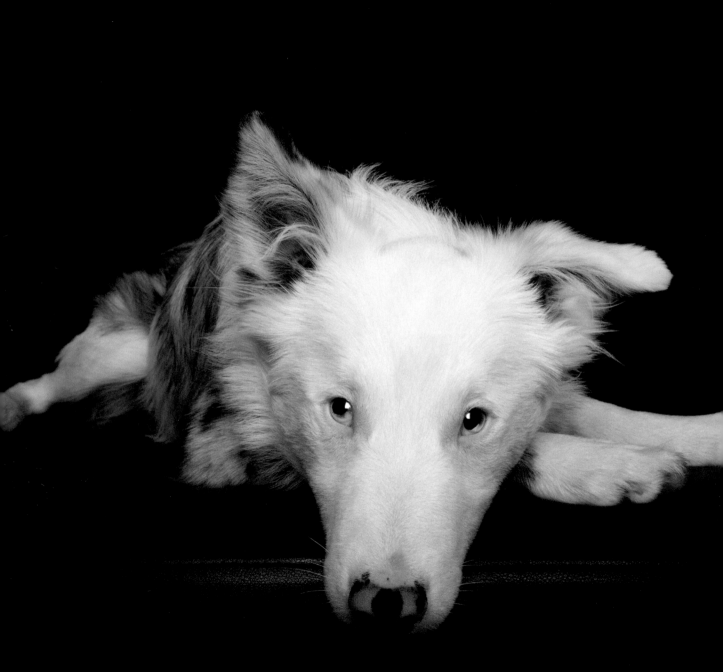

Buzz

12 months old
Cattle dog

Human:
Ashley

Buzz was born on a cattle farm in Victoria. His owners became curious when Buzz didn't stir from his sleep if loud noises woke his siblings. After a series of homemade tests, it was decided that tiny Buzz was deaf.

When his owner contacted me for advice, I knew I had to help and flew to Melbourne to collect him. Rehoming him was the intention but he soon became my foster failure number two!

Buzz means the world to our family. He's shown us and others that his disability is no barrier. That's not to say we'd place him in situations which could cause harm, but in a safe environment he can run and play off-lead without fuss. People are often surprised he's deaf and remark that he's more obedient than their 'normal' dogs.

There are too many words to describe our Buzzy so I'll limit it to 'lively, attentive and gentle'. When he runs freely at the park, the sheer joy and exhilaration is evident. Buzz believes everyone and everything is his friend, but his favourite is his older brother, Ace.

Without a doubt, Buzz has taught us many things. He's also ensured we'll continue to promote deaf dog ownership and we would have no hesitation in owning another.

Dotty

11 years old
Jack Russell

Human:
Bernadette

In February 2016 we discovered Dotty had a melanoma in her left eye. She went into surgery immediately to have the eye removed – the melanoma would have made her go blind as it grew anyway. Having only one eye means she does bump into things occasionally and not noticing people on her blind side can give her bit of a shock.

Dotty is our irreplaceable companion. In typical Jack Russell style, everything is on her terms (especially cuddles). She is also very expressive and vocal when she is expecting something of us, such as a walk or the remnants of our dinner. Even with one eye Dotty has not given up her favourite pastime of hunting for rats (well, chasing anything that moves, basically), running, paddle boarding, eating bacon and going for weekend adventures.

When I picked her up after the surgery she was looking very swollen, wobbly and sore. Back at home, however, I was in the garden when I came across Dotty, who rather than being in her bed inside recovering from her major surgery was outside 'hunting' for rats. That's when I knew she would be totally fine!

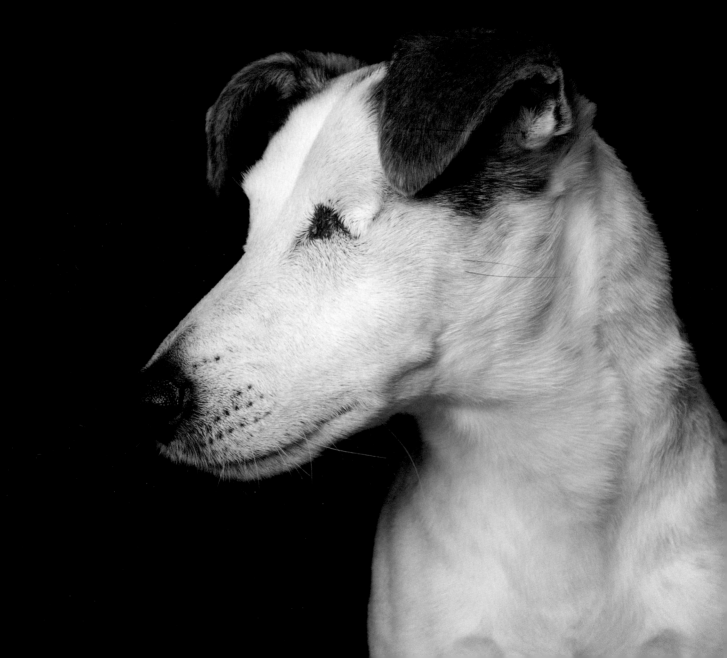

Fudge

**7 years old
Chow x Staffy
x bull terrier**

**Human:
Lindsay**

Fudge was in a house fire when he was just under two years old. He suffered severe burns, from the tip of his ears to the tip of his tail. The family, now homeless and broke, took Fudge to the vet to be put to sleep. But the vet wouldn't give up on him: she took Fudge home to her kennels and dressed his wounds daily for four months. Fudge started to improve and then found a friend. Gympie was a shy border collie and she'd also come to the vet to be put down because of her extreme anxiety.

Fudge and Gympie shared that kennel for four years. Like any couple they had their fights occasionally but overall Gympie was Fudgie's rock. I met them both when I started working there. I fell in love with them instantly.

Fudge hated water. One very hot summer day, I was filling up the paddle pool and Gympie was going in and out of the pool having a ball and trying to entice him in. But Fudge stood beside the pool yelling and howling at me: 'Eoo woo wooooo – I don't like the water!' Next minute Gympie (very unusually for her) gave him a massive nudge and knocked him into the pool. He loved it! The look on both their faces was priceless.

Fudge inspired me every single day. His sparkling eyes were the window to his soul. He never felt sorry for himself, always had a huge smile on his face and never let his pain interfere with his life.

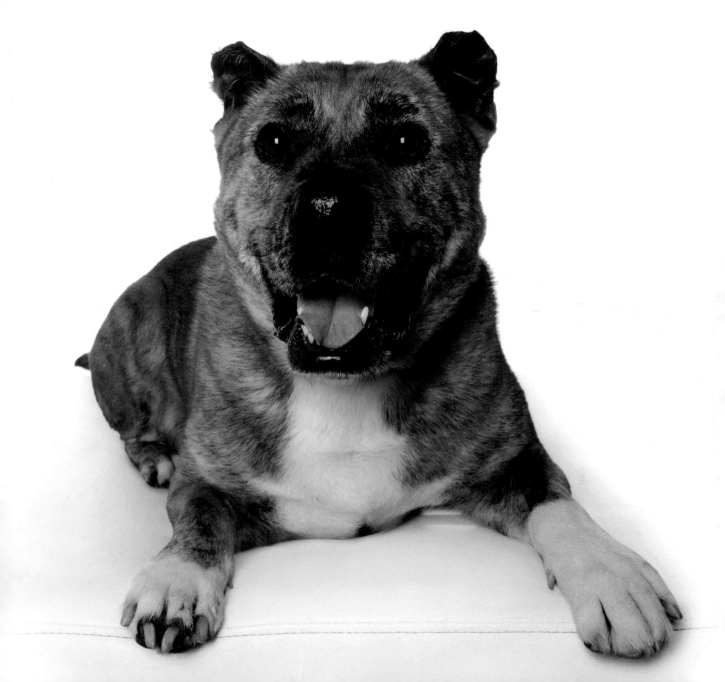

Jessie

8 years old
Australian
shepherd x
border collie

Human:
Karri

Jessie was a very active, healthy dog up until she was nearly 6. While running as usual after a ball in the park, Jessie made a sharp turn and yelped. She had severed her spinal cord in a freak incident that could have happened at any time. The vet described it as a bullet disk, explaining that it was undetectable and not preventable. Jessie was in emergency care for a week while the vets determined whether they could restore movement in her back legs. Slowly we came to terms with the fact that she never would regain that movement, wag her tail or have control over her bowel movements. We tried physical therapy but it stressed her out too much and proved ineffective. Jessie now has a wheelchair to get around outside and drags herself around when she's not out on a walk. We put an adapted nappy on her in the evenings and when we go out for extended periods of time.

She still demands walks and she loves her wheels: she's pretty fast on them and we've had to replace the wheels twice because she wears them out. Her life may have changed, but her quality of life certainly hasn't. The love we have for her far outweighs the extra work that goes into caring for her now. Jessie's accident has made us all realise that you can't let things get you down in life. As long as you have love and determination you can conquer pretty much anything. Including stairs.

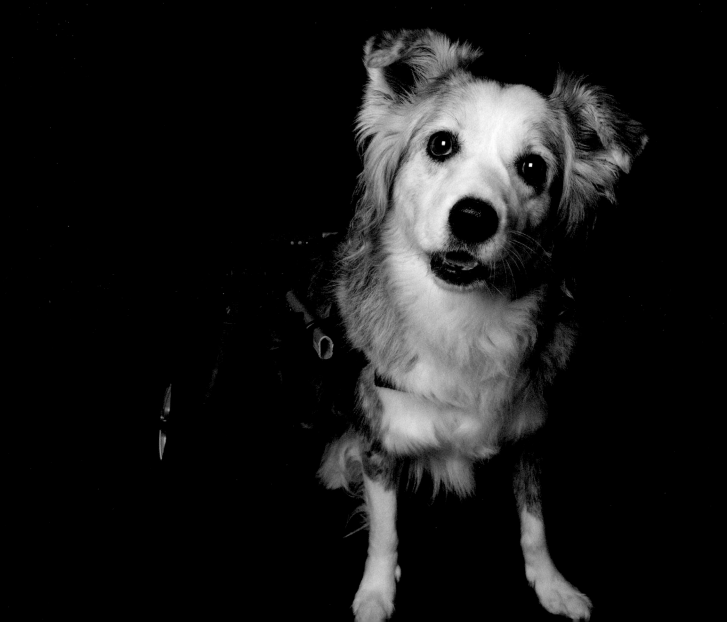

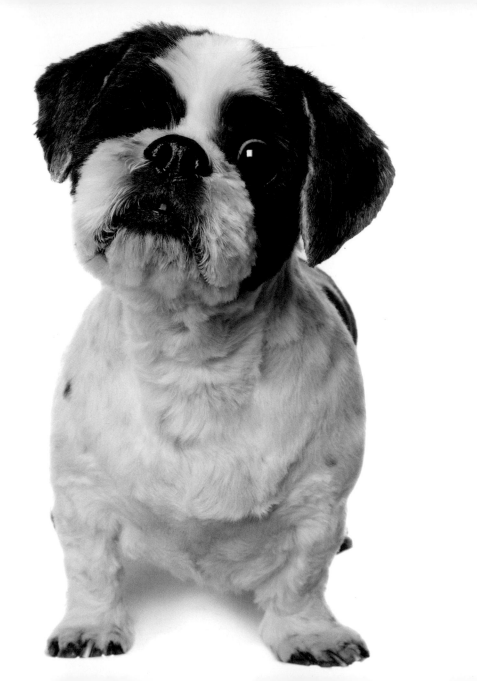

Misha

12 years old

Maltese cross

**From:
HAART
(Homeless and
Abused Animal
Rescue Team)**

Michaela of HAART writes: HAART was contacted by a distraught man who told us that he'd come home from work to find his old family dog tied with rope to his front door, in terrible condition with matted, filthy fur and an eye missing, with a note that basically said kill her or keep her, I don't care.

I rushed over, only to find her in even worse condition than he'd described, and lunging and snapping at me. It turned out the man's ex had taken Misha when she'd left him 12 months earlier. Sadly, the owner was unable to keep Misha, and felt that surrendering her would get her the care she needed.

With pain medication and surgery to remove the damaged eye, a full groom and short toenails again, Misha was a much happier dog. It took a week before she'd let me pat her, but even on the first night she jumped on the couch with me. We gave her as much time and space as she needed, and she came to love her whole foster family.

As she healed, HAART began to look for the perfect home for Misha, and after 18 months finally found it. Her new owner took lots of time getting to know our feisty little girl. Misha was still fearful of new people but she eventually thawed, and we knew it was time for Misha to move on to the next chapter of her life with her new mum.

Penelope and her puppies

Penny:
2 years old
Puppies:
14 weeks old
Staffy crosses

From:
RSPCA WA

Penelope was brought into the RSPCA heavily pregnant and almost bald from a very bad untreated skin condition. Two days before Christmas she gave birth to three pups. Unfortunately this condition affected the pups too and they were almost hairless from an overgrowth of mites. At three months they could be fostered and they were later adopted into new homes. After a course of treatment their skin healed and now they are happy, healthy dogs.

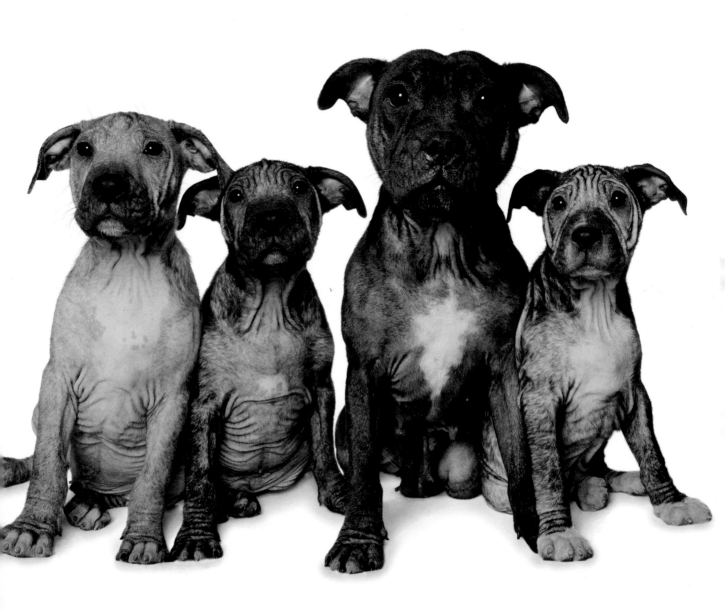

Polly

14 weeks old
Staffy cross

Human:
Lindy

Polly is one of Penelope's three pups (see previous page). Like Penelope, Polly and her two brothers all had mange. Polly's brothers had foster homes lined up but Polly didn't. I didn't want to leave her alone in the kennel so I took her home 'just for the weekend'. My mum thought I'd brought home an alien: she was bald, itchy and lumpy and she stank! But she fitted right in. I cared for her throughout her treatments, injections, tablets and baths – and of course I ended up adopting her.

Polly is a mix of curious, cuddly and cheeky all rolled into one. She gets on well with my other dogs as well as any new friends she meets. She's very smart and motivated to learn new tricks. On walks she'll jump over any hurdle, walk 'tightrope' on brick walls and crawl through any small gaps. So I enrolled her in agility classes and she loves it – she's one of the fastest in the class. Polly has also taught herself how to open doors. Her favourite thing is to open the door on anyone while they're on the toilet, then steal the toilet roll and run!

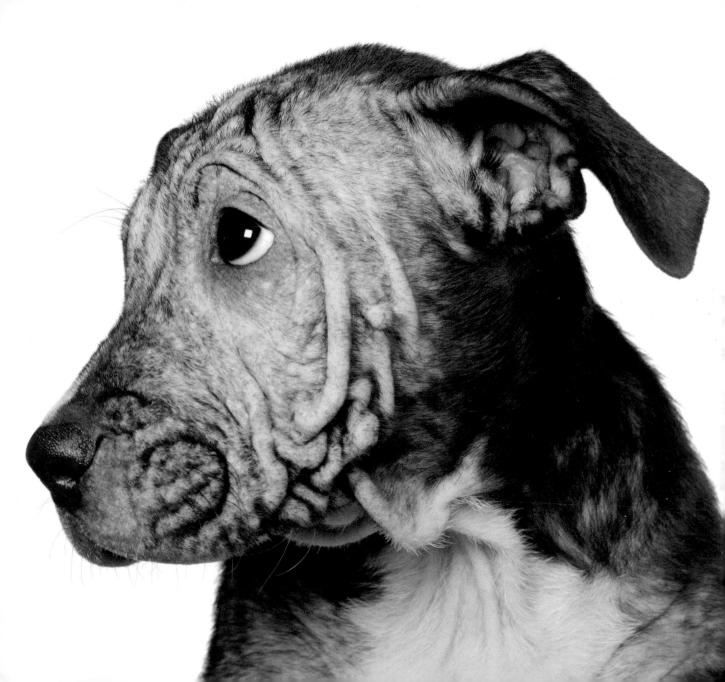

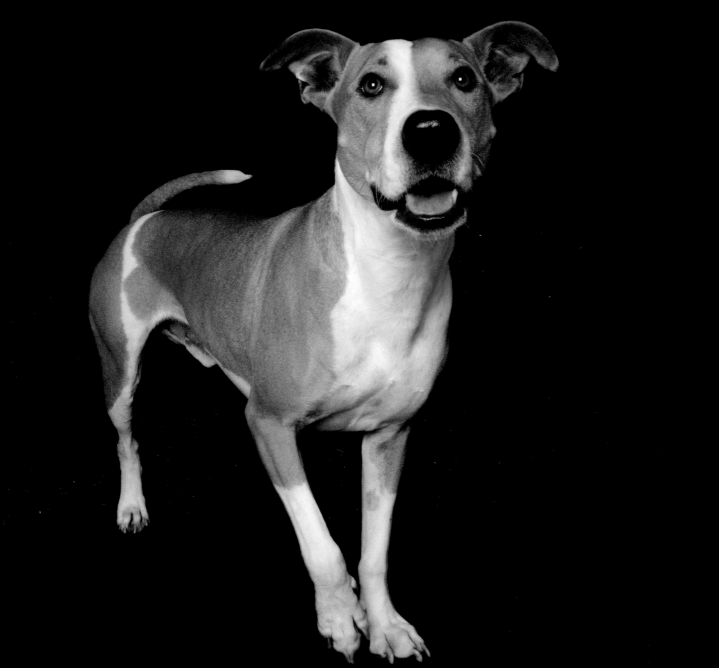

Frank

2½ years old

Fox terrier x Staffy

Human:
Kelly

Frank lost one of his back legs while living in a community in Broome; it was broken in too many places to be repaired.

Frank is part of the family. He's a lazy but funny boy who loves his cuddles but also likes to run and play tug-of-war with his toys.

When Frank joined our family we weren't sure how he'd be with kids and other dogs. But within weeks he'd bonded with my 10- and 16-year-old boys, sneaking into their rooms at night to cuddle and keep them warm. Frank enjoys his outdoor adventures and when we take him to the dog beach he runs free and plays with all the other dogs. He jumps into the water as if he has four legs. Nothing has stopped this boy. He still does everything all other dogs do. Frank has been a key role model for the foster community at the Dogs' Refuge Home of WA by being very welcoming to the foster dogs we have bought home to look after over the past 18 months. We are very proud of our boy.

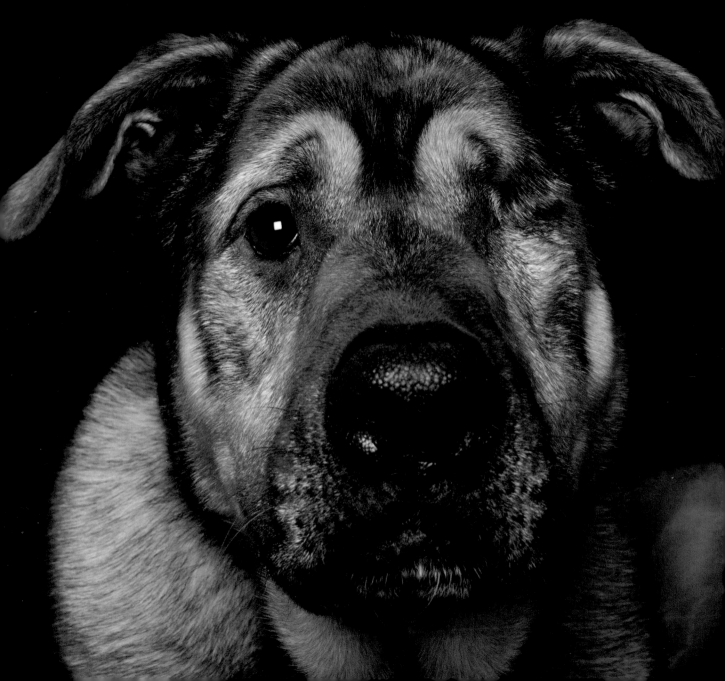

Locki

8 years old
Shepherd cross

Human:
Evelyn

My husband and I adopted our first dog, Kobe, from RSPCA WA and about eight months later we agreed to get him a friend. Off to the RSPCA we went again. We had a pep talk in the carpark: we were getting a small female dog or none at all. We shook on it and headed in. Next thing, a little brown pup came waddling over and proceeded to sit on my husband's foot. He looked up at us and it was love at first sight. We forgot everything we had agreed on: Locki had picked us.

Locki was diagnosed with diabetes mellitus (and hyperthyroidism) when he was 2 years old. As a result, he requires twice-daily insulin injections and he developed cataracts. He had surgery to remove the cataracts, but from the surgery he developed glaucoma and, despite further surgery, one eye had to be removed. Another kicker is that as he's getting older he has retinal degeneration and his eyesight is almost gone again. He has a stubby little tail which was a little birth defect. He's also lost a toe on his foot to cancer.

Despite all his issues, Locki is the most chilled out and loving dog you could ever meet. Even with the twice-daily routine of jabs, the eye drops, tablets, multiple surgeries and a cancer scare – he takes it all on like a champion. He's a big 50kg bundle of cuddly joy.

Zulu

**9 years old
Border collie
x kelpie**

**Human:
Loreen**

Zulu had a fast-growing cancer removed from his back leg. His leg was saved but the margin wasn't satisfactory. I was told his leg might have to be amputated. As fate would have it, the 10-inch wound burst open five days into recovery when he ran to greet a friend who arrived to visit. Emergency surgery was completed that very night and his leg was amputated. His prognosis is now great and he's doing really well.

He's my constant companion, my best friend and my world. Zulu loves life and he loves people – he's a reminder of the beautiful world we share with all its creatures despite the chaos we humans can create.

I was devastated when I was told he needed to have emergency surgery to remove his leg. Zulu looked at me with his reassuring eyes and his smile comforted me greatly. He hasn't lost anything. He's still the same sweet and wonderful energetic beautiful boy.

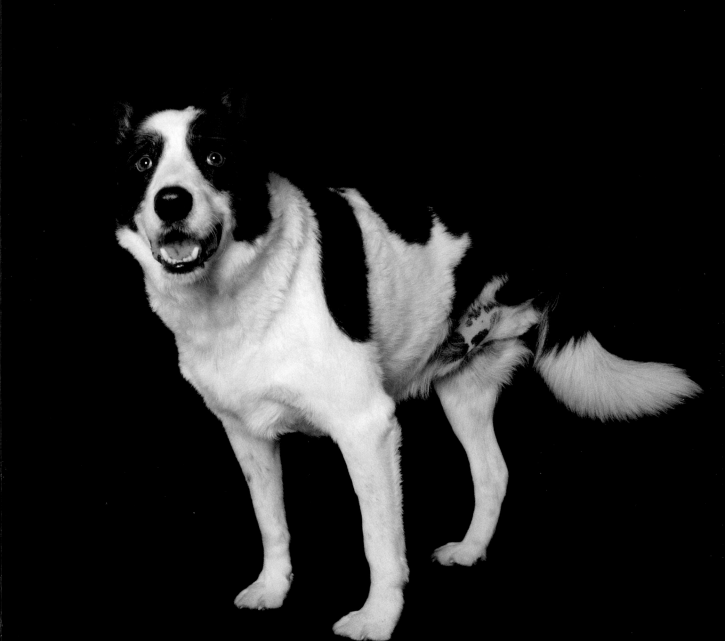

Romeo

14 years old
Chihuahua

Human:
Megan

Romeo's right eye had to be removed after an altercation with another dog on a beach in 2009. It took a few months to fully heal but hasn't bothered him since. In recent years he's also developed back pain and a heart murmur but they're well managed with medication and a gentle lifestyle.

He's the heart of our home. He's sweet and cuddly and pretty chilled out, with a strong conviction that laps must be sat upon and tasty food shared.

Romeo recently had a sudden collapse and was raced to the vet, where it seemed clear that his heart had given out. Told he might only have a few hours left, we took him home and kept him comfy and cuddled. He was weak and slept for hours but perked up when he noticed a shortbread bickie being shared. We thought it a little odd for him to have an appetite at a time like that! But he was also very interested in sharing our pizza dinner – and the next day was raring for a walk!

A week later he was the miracle dog the vet was happy to have been wrong about – but just in case he had extensive specialist testing and so far hasn't shown any new problems. While we have to keep his stress levels low, Romeo has fully recovered and is bopping along, his normal happy self.

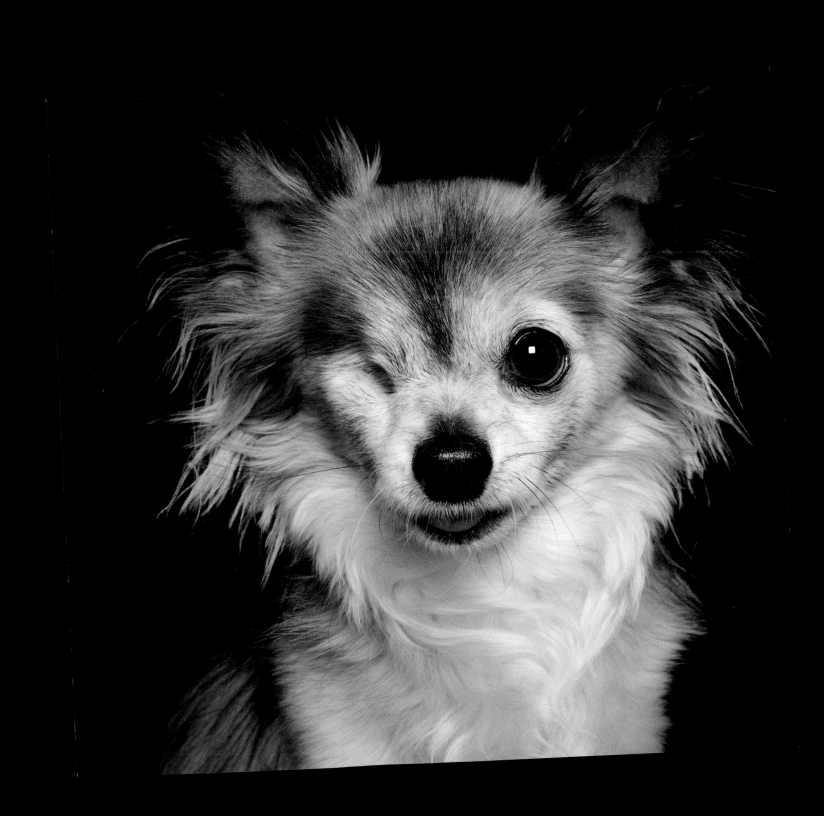

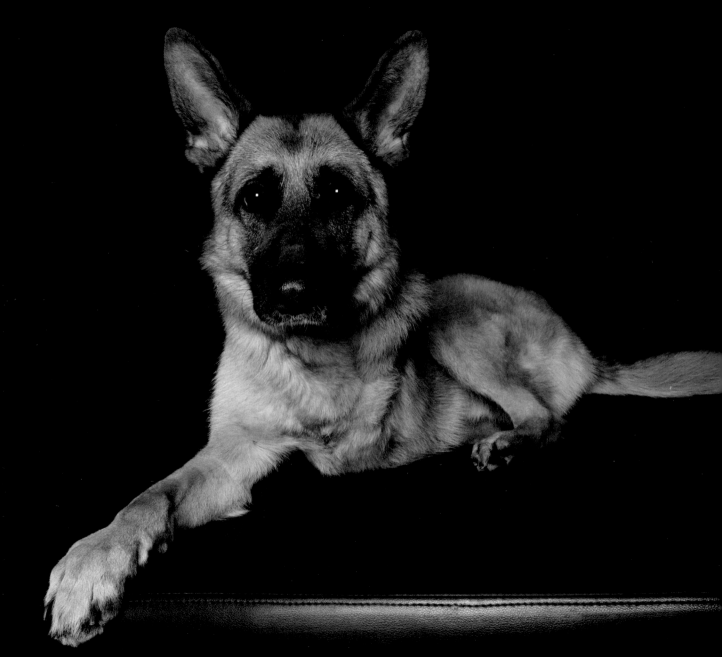

Perse

2 years old
German shepherd

Human:
Bec

Perse had a really nasty accident as a puppy, leaving her left forelimb useless. When I met her, she was facing euthanasia. Luckily for Perse, I have a weakness for broken critters so she came home with me, had her leg amputated and has never looked back.

Perse is the biggest, goofiest most carefree dog I have ever met! She has no idea that she's disabled. She's very happy, loves unconditionally and has something to say about everything. She's been the perfect addition to our family, much to our Chihuahua's disgust, and everyone who meets her falls in love with her.

I work at a vet clinic where Perse is lucky enough to come to work with me most days. We had an emergency case come in that needed an urgent blood transfusion and we didn't have any spare blood in the fridge. Perse stepped up, donated blood, had her post-donation tea and bickies and continued to steal pats from clients for the rest of the day. She saved a life and never even missed a beat. Not bad for a dog that was very close to not being here herself. She has more love and more heart than many four-legged dogs I know. Perse is a true example of a dog being born with three legs and a spare, and we wouldn't have her any other way.

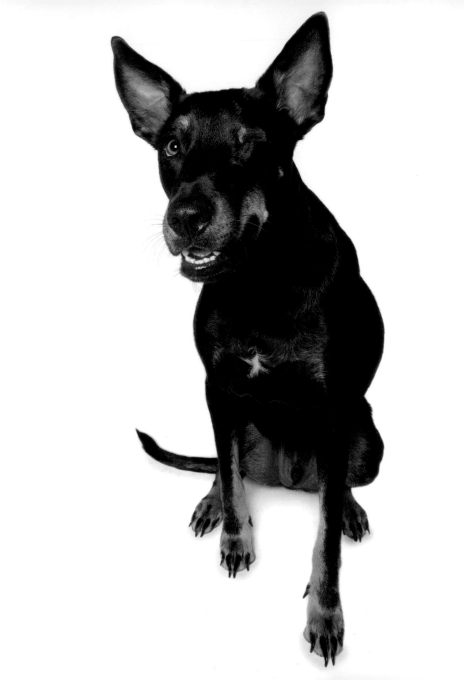

Odin

12 months old
Kelpie x Staffy

Human:
Stephanie

Odin lost sight in his eye when a littermate accidentally scratched him soon after he first opened his eyes. His name came from the Viking god Odin who gave up the sight in his eye for wisdom.

Odin meant everything to me. He was my shadow, my son, my special little boy. He was incredibly sassy, liked to tell stories and just had this attitude that said 'I'm the big man on campus.' But he had a soft streak; he loved cuddling up super close and resting on your shoulder.

After he was born we visited him every weekend to get to know him and he was so small he used to sit on my shoulder and sleep, or in the hood of my jumper. Even as he got bigger he still liked to be on or at your shoulder. He was like a hairy parrot!

Rowdy

6 years old
Australian shepherd

Humans:
Claire & Chris

Rowdy was diagnosed with cancer of the bowel and needed surgery as the cancer had perforated her stomach. As a result of complications with surgery her paw became infected, the tissue started to die and the paw had to be amputated.

She was the best! It took a few years for her to calm down but she was full of energy and loved everyone. She was so super excited to see any person or dog. She loved to lick a face and was so patient with our young daughter climbing all over her. She was my best buddy and wouldn't leave my side – sometimes she stayed so close I'd trip over her as she followed on my heels. She loved to run and became my running buddy; we enjoyed running in the bush and on trails.

After her paw was amputated I thought it would be impossible for her to get around, let alone up the stairs. But it only took her a day to get it. On the first attempt she took a bit of a tumble but she was so keen to get to the park, even the day after the surgery to remove the paw, she didn't mind. After the first day she powered up the stairs. It just shows how adaptable dog are.

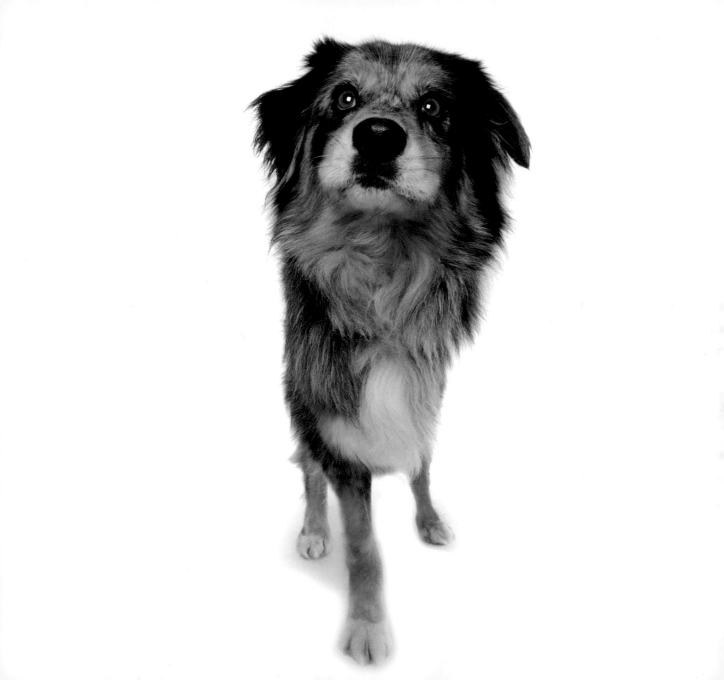

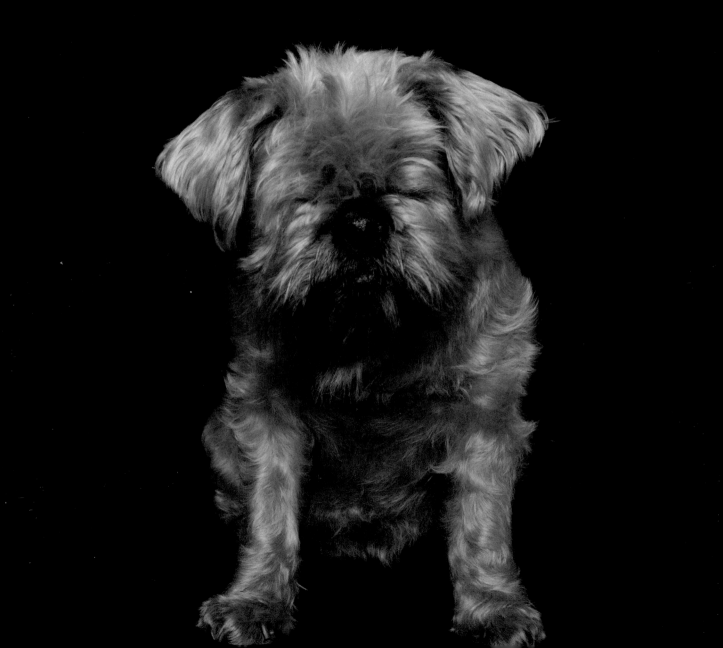

Lady Bug

**12 years old
Griffon Bruxellois
(Brussels griffon)**

**Humans:
Vickie, Ryan
& Ryan's mum**

Lady first came into our lives in 2009. She was a former show dog in need of a new home, and we got her to be good company for my mother, who'd never had a dog before. They are now inseparable.

Lady lost an eye to glaucoma in 2011, and we were deeply saddened when we learned that she was developing glaucoma in the remaining eye. Despite every effort and expense to save her vision, she had to have her second eye removed just before Christmas 2014. We needn't have worried though, as blindness has barely slowed her down.

Lady has no trouble making her way through the house, down the back stairs out to the yard, stopping off at the drinking station, and making her way back. You'd think she has sonar! She still loves going out for walks and does so with great confidence. Lady is truly an inspiration, and continues to amaze us as she enjoys life in the dark.

Geri

12 months old
Mixed breed

From:
Dogs' Refuge
Home of WA

Geri came into the care of the Dogs' Refuge Home of WA via a call from MayDay, a rescue group we work with. She was not weight-bearing at all on her leg but didn't seem to be in pain – it was clearly not a recent injury. We sent her off for tests but they said her muscles had degenerated so badly there was no point in trying to fix it as she would never have the strength to use it again, so we amputated. Geraldine was adopted by her foster carers who fell in love with her.

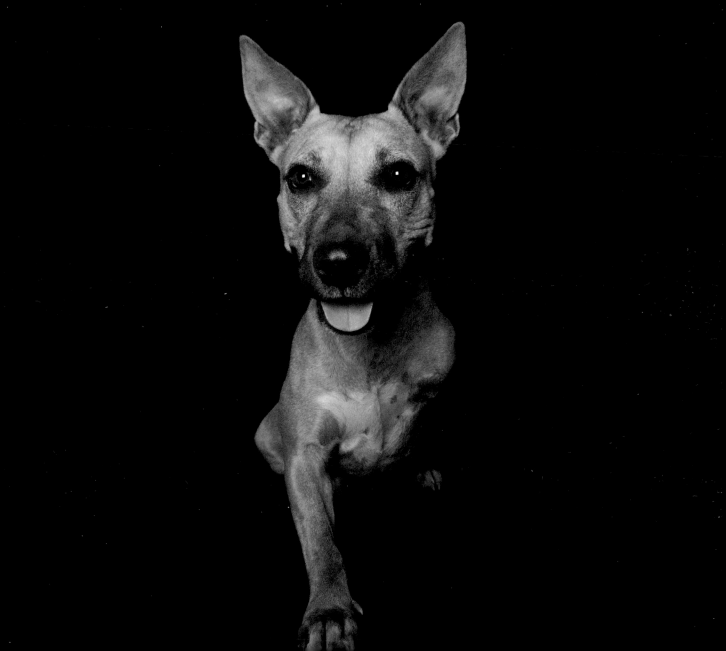

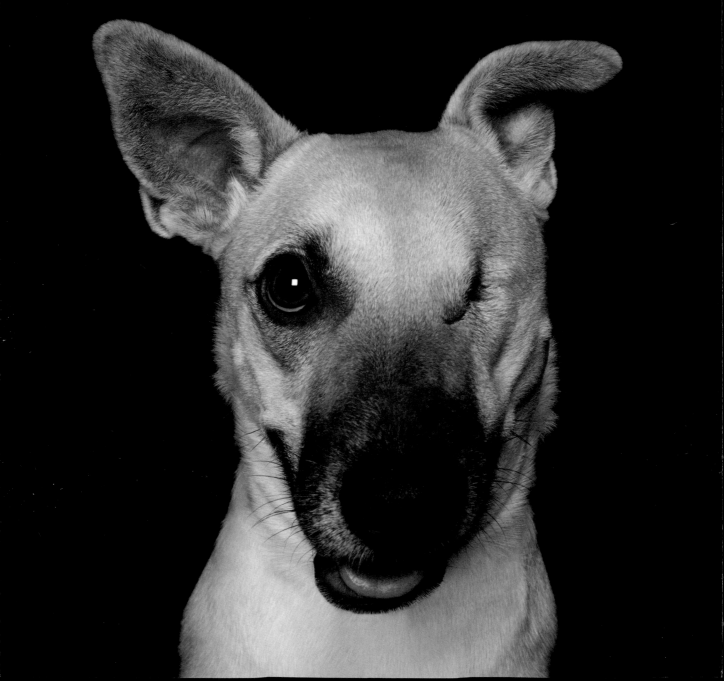

Aryah

18 months old
Mixed breed

Humans:
Julie & Pete

Quirky. Adorable. Affectionate. Chatterbox! These are all words that describe our little Aryah.

Aryah came into foster care at 6 weeks old, a very sick puppy with a lot of problems – she had severe glaucoma and was partially deaf, with cranial deformities and learning difficulties. She had no mum to nurture her or show her how to be a dog and she'd never met a human before. But within hours of coming into our care, Aryah started to show her fight for life and quirky personality.

She was so weak and sick she was barely able to walk around, but one day I was looking everywhere for my shoes and found them at last – in Aryah's bed, with Aryah snuggled up inside one of them!

I felt then that Aryah had chosen us as her forever family. Ever since, the bond she shares with us (her humans) and her fur sister and brother has become stronger and stronger every day. To us, Aryah is perfect.

Mya

**9 years old
Siberian husky**

**Human:
Pia**

Mya used to have lovely bright blue eyes. About five years ago she contracted glaucoma which made her blind. Her eyes started causing her pain, so I made the decision to have them removed. She's now pain-free and is loving life.

Mya is a very placid, friendly, happy-go-lucky dog, and very lovable. She has aged well – people think she's still a puppy.

Mya loves her squeaky toys, especially a bone and a snake. She has a special rug for indoors and she loves to play. She also has a close friend named Ozzie the cat and they sleep together. Mya loves car rides, especially to the beach and parks. She runs free – literally runs! It's beautiful to watch. Mya goes wherever I go – whether it's a trip away or to visit friends. Everyone loves her. Mya gets around exceptionally well as all of her other senses kick in. She means the world to me. I'm so glad we have each other.

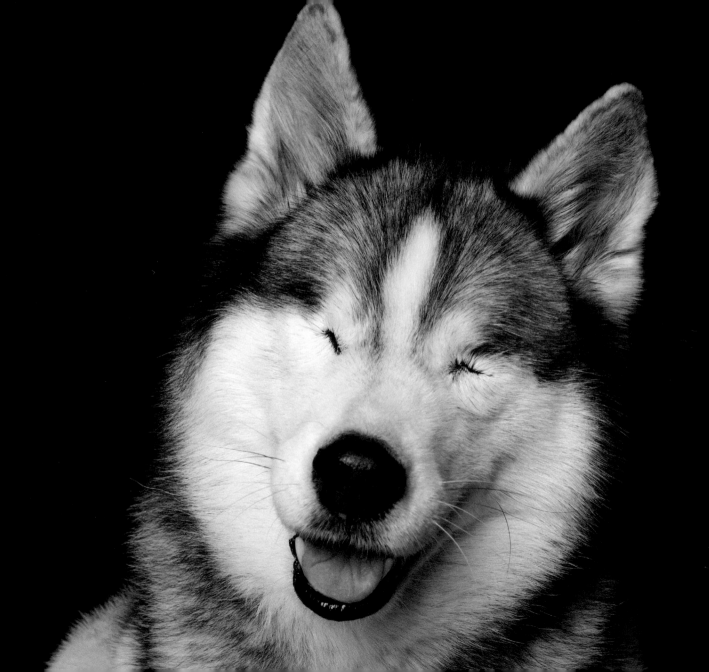

Tiki

12 months old
Husky

Human:
Madilyn

Tiki was the result of an unethical backyard breeder who left him with serious untreated injuries and illnesses. He had a broken tail, a shattered leg and a tender abdominal mass consistent with internal bruising. He was tiny, skinny, scared, and starving as a result of an untreated enlarged esophagus.

He's funny, cheeky and extremely embarrassing when back-chatting me in public. He's a real charmer who has his angelic 'love me' face down pat and he always has everyone saying 'aww' wherever he goes.

Thinking back over all the things we went through together, it doesn't seem real any more. He's so normal now after all that work, his problems seem a thousand years ago. Although he makes me laugh every day, he's so inspirational too.

He had a terrible start to life and a despicable introduction to heartless humans, yet somehow in his little heart he found a place to trust me. He beat the odds. He reminds me every day that rescue dogs aren't broken. They just need someone on their side to show them love. He reminds me to push further and try harder and for longer to save those lives that others deem unable to be rehabilitated, or managed, or saved.

Mia

2 years old
Bali breed

From:
BAWA

Janice Girardi writes: I founded the Bali Animal Welfare Association in 2007. A few years ago, I was feeding a pregnant dog in a local market. It was monsoon season and one night the market was flooded. I couldn't find the dog so I called her and she barked. I followed the bark through the flooded filthy rat-infested market till I finally found her. The mum had given birth, and as I was feeding her, a little nose stuck out from under a pile of rubbish. I scooped this second dog up soaking wet and shivering, and took her to my car. I soon realised she was completely blind: her eyes appeared to be badly infected but veterinary assessment confirmed that Mia was born blind.

Mia is a sweet and loving companion and doesn't let her disability hold her back. I'd never had a blind dog and wasn't sure I could manage but Mia is amazing. Two years later and she is still quite independent. We walk her down to a field every day to play with other dogs and she gets on just fine. She lives in our BAWA shop so she gets lots of attention and cuddles and a bit too much food!

Sarai

**5 months old
French bulldog**

**Human:
Tahnee**

Sarai was born with a 'little' leg. Her left foreleg is shorter and skinny and has a 'stump foot'. Her paw isn't formed, and she has no toes (which makes nail clips nice and easy). She has an obvious limp and is often seen with her left foot up because it doesn't touch the ground, but she doesn't let this get in the way of her life whatsoever.

Sarai is a great joy in my life. She makes me laugh daily and is very cheeky!

Sarai has two big mastiff brothers named Jonah and Gabriel who weigh in at 60kg each. That's a massive size difference compared to Sarai's little round 7kg body. But she's the boss dog of the family and always puts her brothers in their places. She makes me smile because having a disability doesn't change Sarai's outlook on life. She's a little dog in a big dog's body. Sarai is very loving and friendly to everyone she meets. She loves life and is always smiling. Although she has giant ears, Sarai doesn't listen. She also confuses words pretty easily. She thinks 'stay' means 'run away' and 'no' means 'yes'!

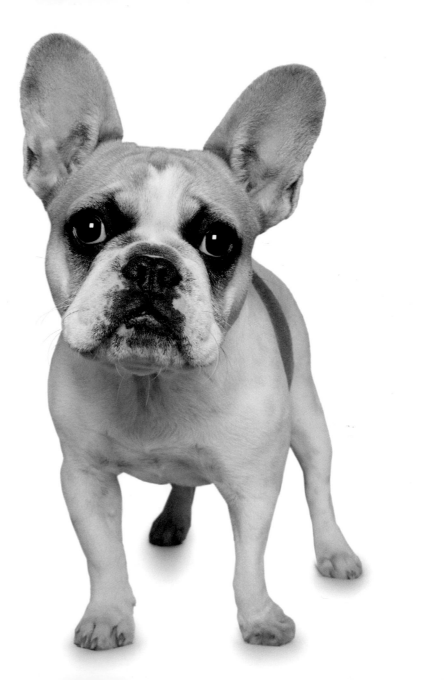

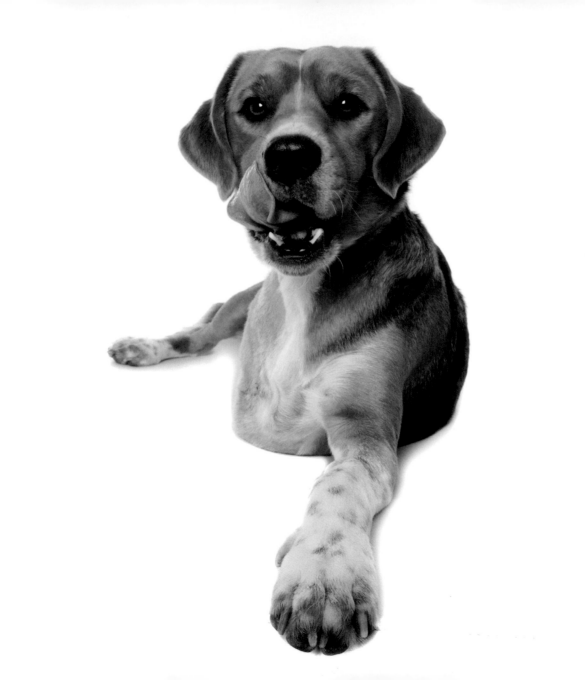

Scooter

4 years old
Beagle cross

Human:
Cassandra

Scooter had his front leg amputated when he was in the care of the Dogs' Refuge Home of WA.

Scooter was the naughtiest beagle I've ever known. He would open an oven and eat the food out of it; he would open the cupboards and eat everything inside. He was my Scooter boy who will always live on in my heart. He was mine the moment I met him. He had the best smile – and he was always smiling.

Nothing ever stopped Scooter, not even his missing front leg. He would run with the fastest dogs at the park and keep up with them.

Scooter pulled me through a lot. He was always there for me. I worked with him and he responded so well. I miss my goofy boy every day.

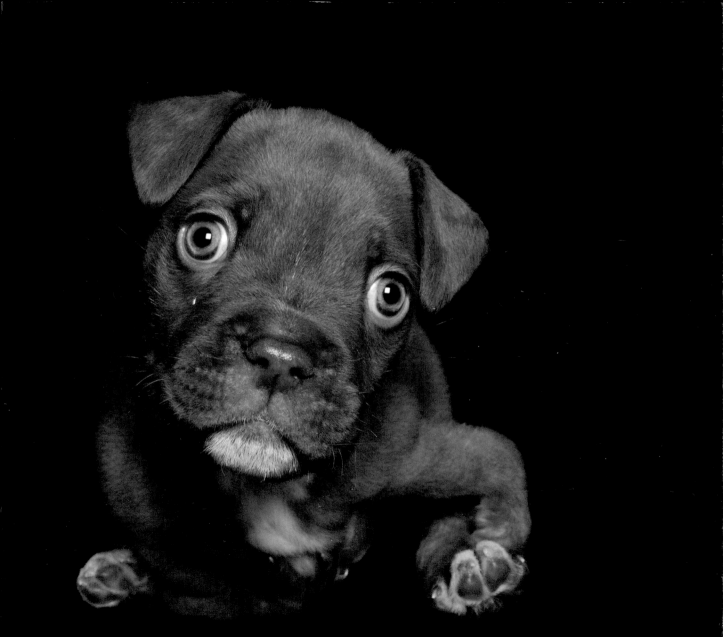

Jakk was only a few days old when he was found in a skip on 5 April 2016, in Baldivis, Western Australia. His umbilical cord had only just fallen off and his belly button hadn't yet healed over. He was probably dumped because of his deformed front legs. He's often likened to a T-rex or a kangaroo, and from his photo you'll see just why.

Jakk's first few weeks were spent receiving round-the-clock care from me. He needed bottle-feeding and help toileting as well as lots of cuddles and love. (He got that in bucketloads.)

After lots of specialist advice, we're hopeful that at least one of Jakk's front legs can have surgery to achieve better function. We're waiting for him to finish growing to decide on the surgery and also finalise a new set of wheels for him to terrorise the neighbourhood with. I've decided that life just wouldn't be the same without Jakk, so he's staying for good.

Jakk is pure joy. His zest for life is infectious and he's without a doubt the happiest dog I've ever fostered in my eight years of being in rescue. To me, Jakk means hope. He reveals the best and worst of humanity,

Hannah was rescued by Greyhound Angels after sustaining significant damage to her shoulder during a race. Hannah's shoulder and entire leg were removed and she healed from her injury in foster care before coming into our home a few weeks post-surgery.

She's a funny, silly greyhound who doesn't let anything stand in her way. She can jump confidently and is as fast on three legs as any four-legged dog. Hannah is the kind of dog that will sneak into your favourite spot on the couch then give you her best puppy dog eyes for a pat.

Hannah loves jumping into the car to go on adventures. One day a friend who'd been visiting left her passenger door open to load the car. After saying goodbye and hopping in, she looked over and there was Hannah – all curled up on the passenger seat ready to go for a drive! Now we're always careful about keeping car doors shut.

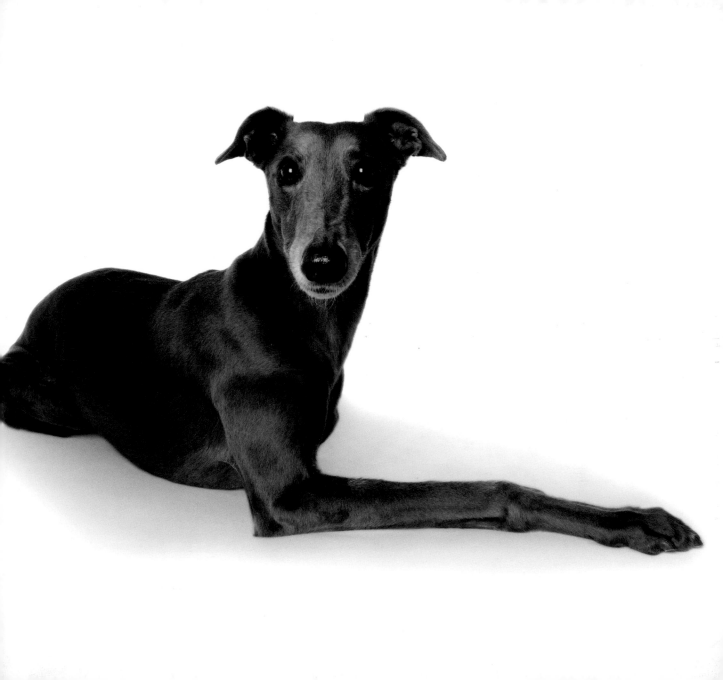

Sam

6 years old
Staffy x ridgeback

Humans:
Darren & Tracy

We noticed Sam's photo on the Homeless and Abused Animal Rescue Team website and contacted them for a meet and greet. We didn't know he was blind in one eye from the photo, just that he looked as if he was smiling. We were told that he was an escape artist with a history of separation anxiety, but his foster mum and dad reported that he'd been good with them. We don't know much more than that he didn't have a great start and that he'd been in an accident involving a car, causing the loss of many teeth and the sight in one eye. Darren and I knew it was love at first sight but we tried to be sensible and left it a few days to really be sure. Within two weeks we got him home and we still keep in touch with his foster parents Kim and Paul.

He's our world and we're his pack – he's is our fur baby! Despite the incident with a car, Sam loves to go out for drives. He bounces whenever he sees people he knows and even people he doesn't. He is a big boofhead but knows when to be gentle, especially around people who are nervous of big dogs. He's a gentle giant and has been amazing with a nervous foster dog and with our current rescue dog, Missy Moo.

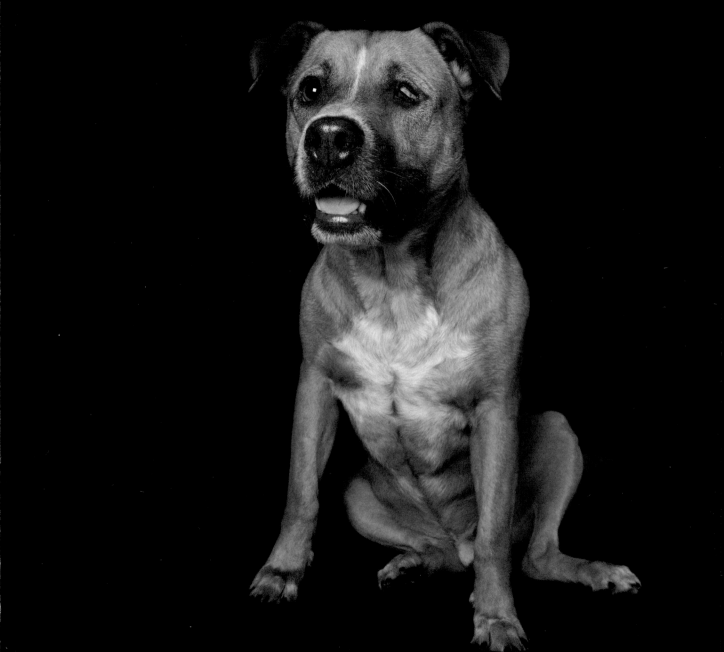

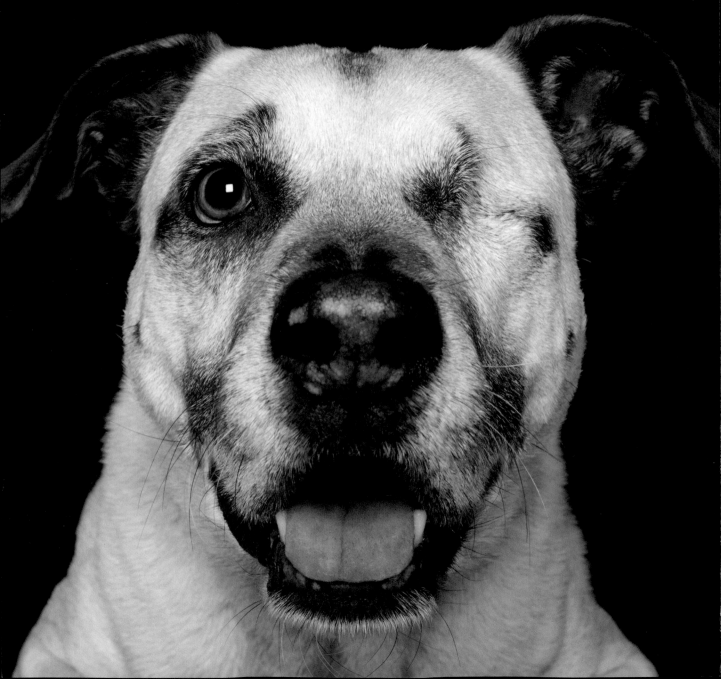

Bender

**11 years old
Mastiff x Staffy**

**Human:
Jet**

Bender's my best mate and partner in crime. He's the only dog I've raised from a puppy and he's been with me for 11 years. I'm not sure how it happened, but about two years ago he damaged one eye so severely it had to be removed, and he began his career as a pirate. Bender's a happy, boofheaded clown with obsessive compulsive disorder – ie a toy obsession!

Bender started a few new hobbies later in life and one of those was dryland dog sledding. There's a longstanding tradition that the last dog home in a given class gets a 'red lantern'. In his first year of racing, aged 9, Bender ran every race held in WA, and he never came last! After he lost his eye, I only raced him once, and he was chosen for the Veteran class Fuddpucka Award – for the dog who keeps on running just because they still can. With one eye and at 10 years of age, he still avoided that red lantern!

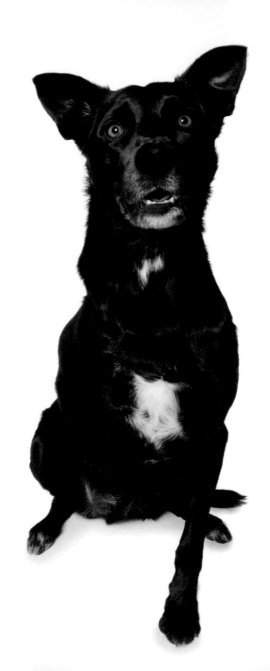

Boris

5 years old
Kelpie cross

Humans:
Stephanie & Alan

Alan writes: Boris was the one who shouldn't have made it, the runt of the litter. When Steph went to rescue a pup, the litter was jumping up excitedly, wanting be picked up – all except Boris. He was cowering in a corner, shying away from all the commotion and without doubt the weakest. Steph obviously chose Boris, probably for those very reasons.

Around the time she got Boris, Steph was battling depression. Boris gave her a reason to get out and about again and brought some joy and laughter back into her days. I think in many ways they saved each other and that's why the bond between them is so unbreakable.

Two years ago a bandage was applied too tightly to Boris's leg, causing a tourniquet effect on the limb, and he nearly died from septicaemia. After the leg was amputated to save his life, Steph and I nursed him back to health.

Boris has always loved to swim. If we're walking along the beach, Boris will swim the entire length with us, well out into the water. When he finally makes his way to shore, onlookers' jaws drop when they see he's missing a limb – he's a stronger swimmer then most four-legged dogs.

How wrong I was to assume he was the weakest runt: he's stronger than I could ever have imagined or hope to be myself.

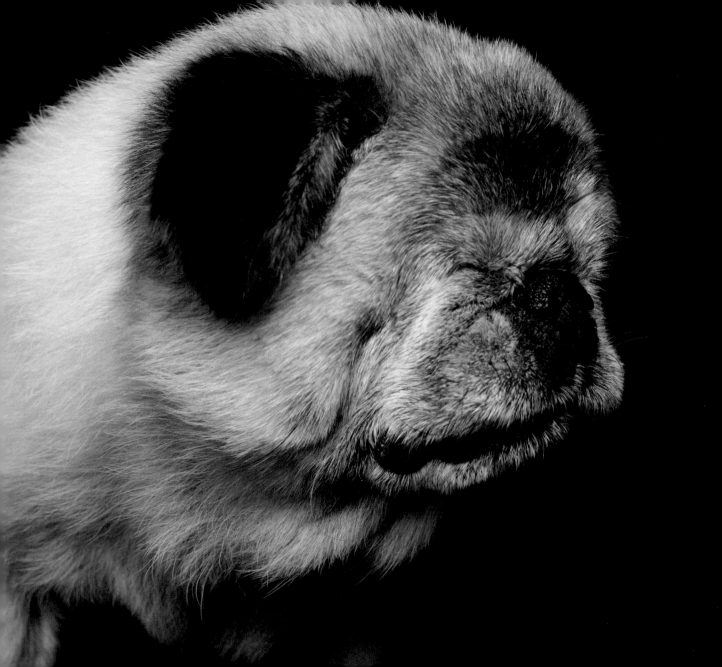

Shazza

13 years old
Pug

Human:
Leeann

Shazza had numerous eye ulcers in her lifetime. She had incredible vets who did eye surgery to help her. Unfortunately, Shazza's good eye was also damaged, which resulted in her losing the eye. As she aged, Shazza lost her hearing and had arthritis and hardly any teeth.

Shazza was so loyal and happy. She would follow us everywhere and slept in our bed since she was a puppy. She was very brave and never cried, although she turned into a different dog and became very cranky when her nails were being clipped! (This involved numerous hands to get the job done and fur flying everywhere.)

Shazza loved people (especially men – she was a bit of a flirt) and always had to have the last word and cuddles on laps. Shazza meant the world to us and is sadly missed.

Oompah

**12 months old
Sharpei cross**

**Human:
Claire**

Oompah was picked up by the Dogs' Refuge Home of WA in a terribly abused and neglected state. She was dangerously underweight, extreme mange had caused 80 per cent of her hair to fall out, and she had many other problems. She was so far gone that if the DRHWA hadn't been a 'no kill' facility, she would have been put to sleep. When Alex took this photo of her and it was shared on social media, she received help from hundreds of people to pay for her medical bills and I believe to this day she still tries to thank every single one of them.

Oompah has this way with people: she will sit in front of them, put one paw on their chest over their heart and gaze into their eyes as if staring into their soul. Soon that person is hugging Oompah with all their might, and she accepts it with all hers. One time she trotted up to a homeless man and sat at his feet. The man knelt, Oompah performed her routine and the next thing the man was hugging her. Then he looked up at me with tears in his eyes and said, 'I can't remember the last time I was hugged, I really needed that!' He got up, thanked Oompah and went on his way.

The more love Oompah received and gave, the healthier she became – so much so that her hair grew back longer and fluffier than anyone expected. She has become a lion!

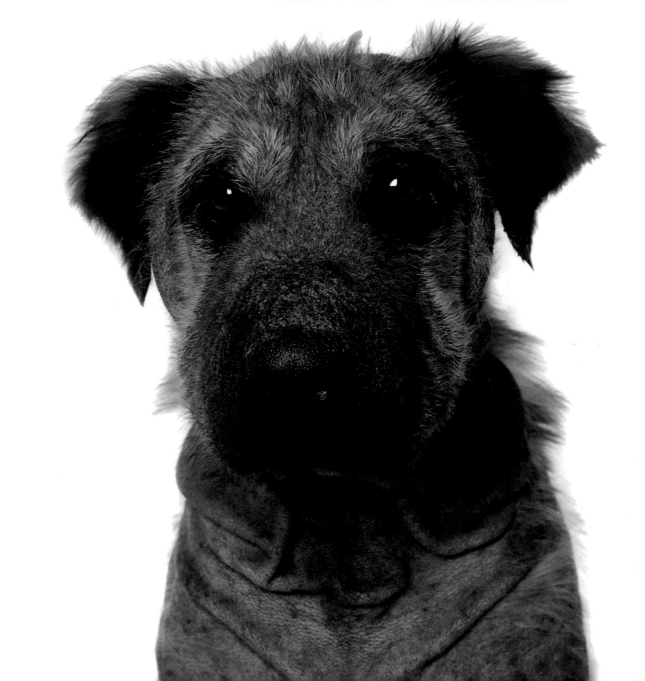

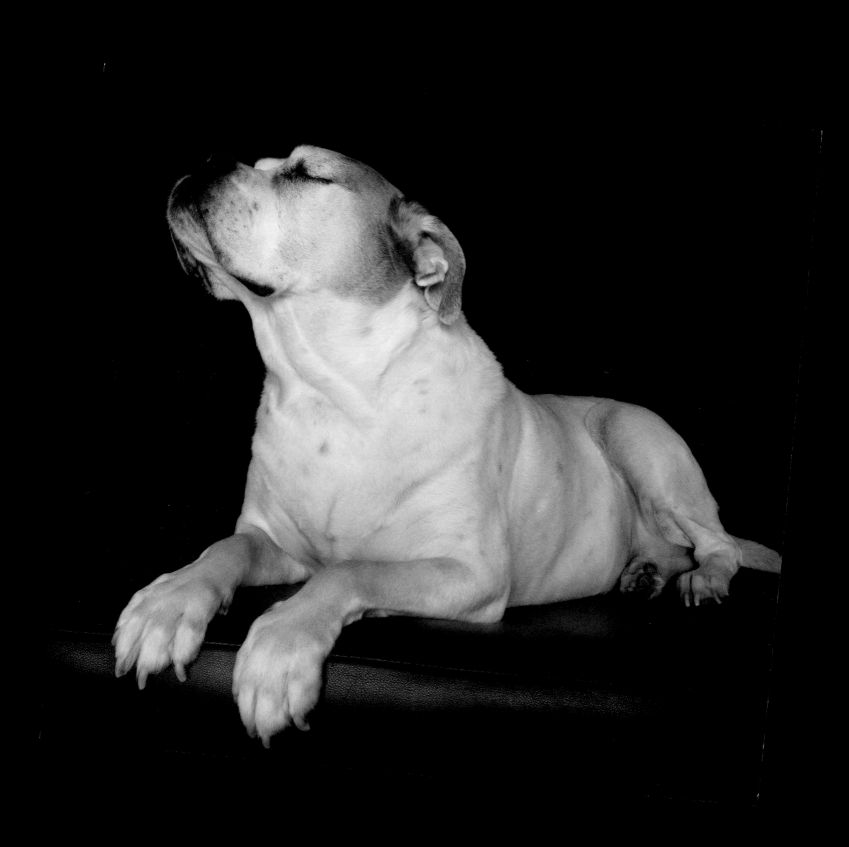

Frankie

12 years old
Boxer x mastiff

Human:
Gina

I became a rescue mum to my beautiful girl Frankie when her previous owner could no longer care for her. Frankie only has one eye following the removal of a tumour. The moment I met her, I knew she was going to be with us for the rest of her life. We picked her up the following day – the day we moved into our new house. She's celebrated our engagement, our wedding, the birth of our son and two house moves with us.

Frankie is about 12 years old now. She still acts like a puppy at times and loves the attention she gets from the kids on the street. She is always by our side, and always will be.

Spike

**4 months old
Stumpy-tailed
cattle dog**

**Human:
Nicky**

Spike was abandoned at a camp where many of his littermates and his mum died from parvovirus. He was starving and emaciated, he had untreated mange, and his skin was dreadfully infected. The vet said another day and he wouldn't have survived. Luckily a camp elder contacted the rangers who contacted Best Friends Animal Rescue. In the photo, he looked so miserable that when I asked my partner, Ron, if we could foster him he couldn't (for once) deny me.

Spike came to us scared of other dogs and also our feet, as he had been kicked. He sat in our kitchen with his head hanging low, totally shut down and having given up on life. The next day when I prepared his breakfast his little ears perked up – he realised his life had changed. I cuddled him and played with him despite his dreadful condition, as all puppies deserve love. We foster failed and kept him! We didn't know if he would ever have hair but that didn't matter – he was part of our family. After weeks of baths every two days and 16 weekly injections for the mange he made a full recovery. It breaks my heart when I hear of other dogs euthanised for mange when it's so treatable.

These days Spike has a beautiful coat. He's now best friends with our other dogs and loves our cats.

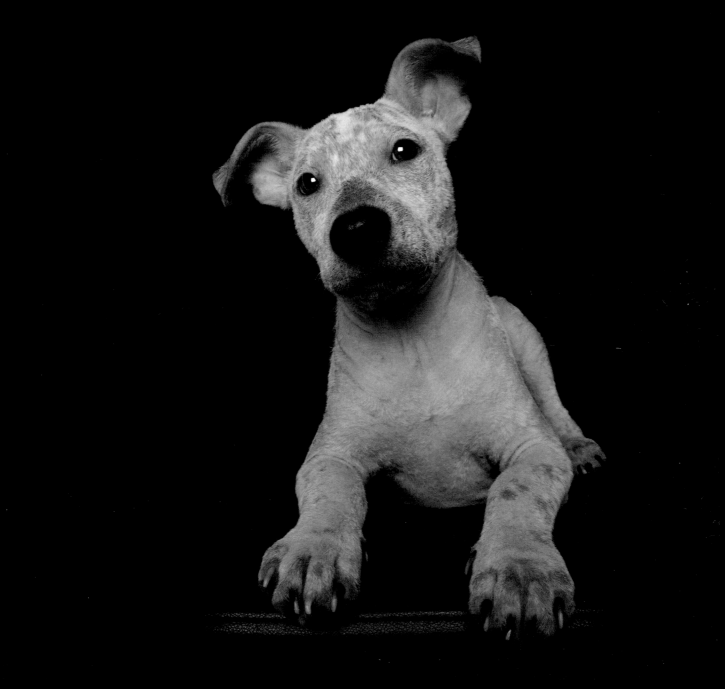

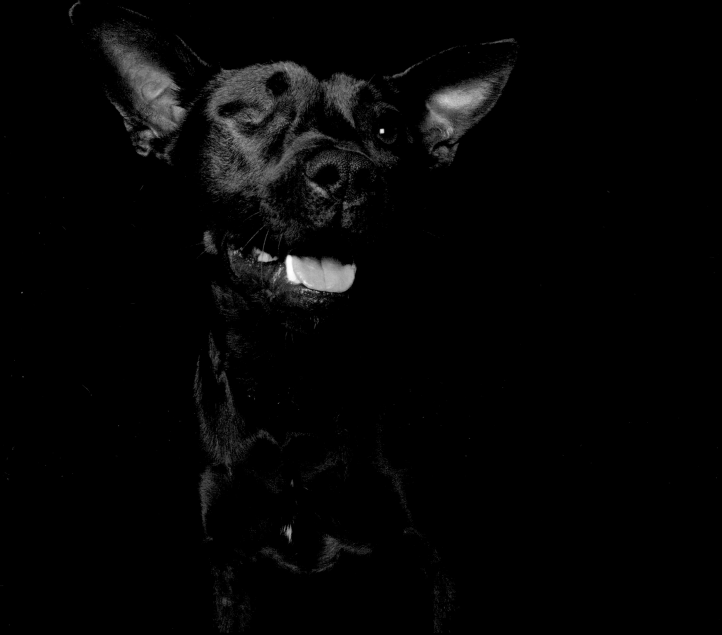

Alluna

2 years old
Staffy x kelpie

Human:
Renee

While at the rescue shelter, Alluna endured a painful eye ulcer. After much medication and attempted corrective surgery, the decision was made to remove the damaged eye.

Alluna is my soul mate; the other half of my heart. She's taught me so much and inspired me to find friends and adventures that I never would have alone. She's not 'just a dog' – she's a familiar friend who provides unspoken comfort and an incredible, resilient being. I respect Alluna and love her just the way she is: she's endured so much in her young life yet still opens her heart to trust and love all that's unfamiliar to her. She has the perfect balance of strength of character with a gentle and caring nature. Alluna has taught me to never give up.

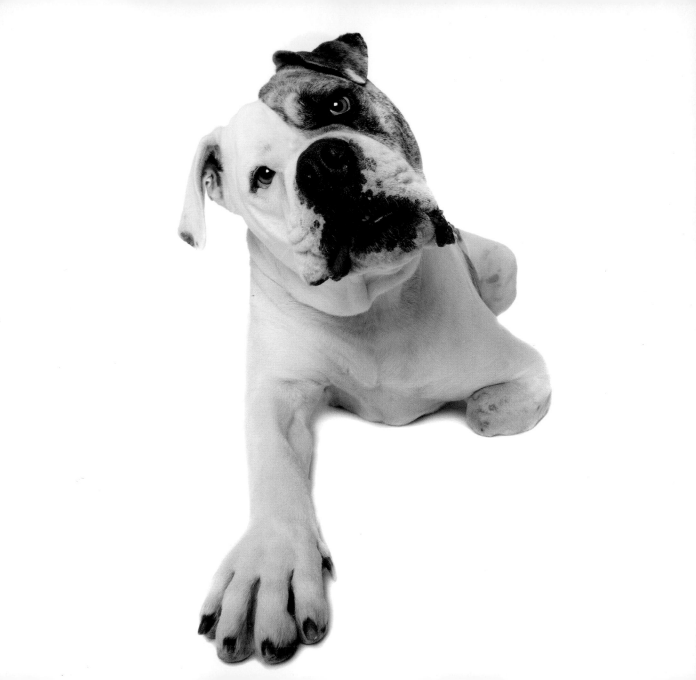

Brutus

7 years old
Bull Arab (I think!)

Human:
Honi

I'm Brutus's fourth owner, having adopted him from Saving Animals from Euthanasia Perth. When he was 3, Brutus was struck down by osteosarcoma in his left front leg, leading to amputation. He was fitted with a prosthetic leg.

Brutus's personality truly reflects his determined yet gentle and loving nature. Our bond is effortless. He protects me and I protect him. We simply complement and care for each other in a way that completes the balance.

Brutus always attracts the attention he deserves, whether it's hanging his big boofhead out the car window to catch an onlooker's smile or simply showing his strength and determination, refusing to give up on himself despite all he's been through. This is what makes Brutus so special to me.

Vegemite

5 years old
Japanese chin
x Pekinese

Human:
Chantelle

When Vegemite was around 3 years of age he was attacked by our other dog. His injury was horrific and his eye was hanging out. We rushed him to the vet but they couldn't save the eye.

I was worried at the time how I would feel about him with one eye but then soon realised he was still the same Vegemite, just more special. He's adapted so well and loves watching TV, especially when animals are on. He sleeps in our bed every night, stealing the pillow, and is always by my side. I would be so lost without Vegemite. He is definitely part of our family.

His favourite toy is a flea. He's had it since he was a puppy and gets in these critter moods where he shakes it around and does what they call the 'chin spin' because Japanese chins are known for that. It's so cute. To be honest I think we love him even more with his one eye – it's as if he's winking at us all the time. Vegemite is brave, loving, loyal, cheeky, and smart. And we are very lucky to have him in our lives.

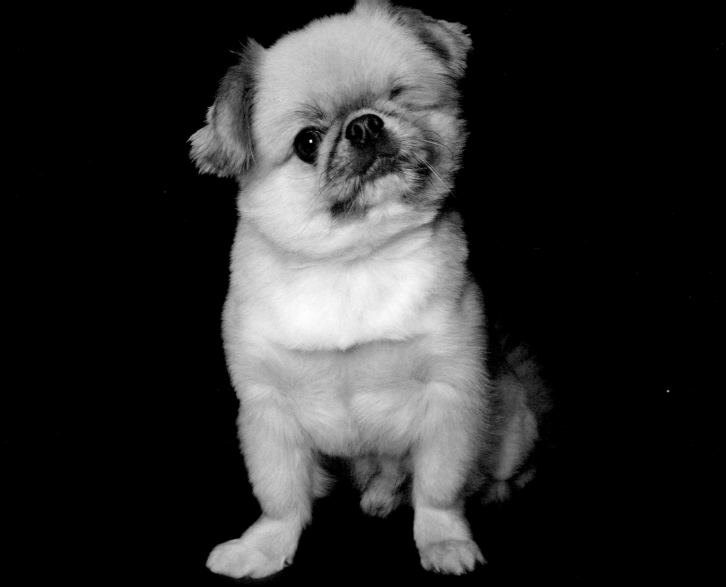

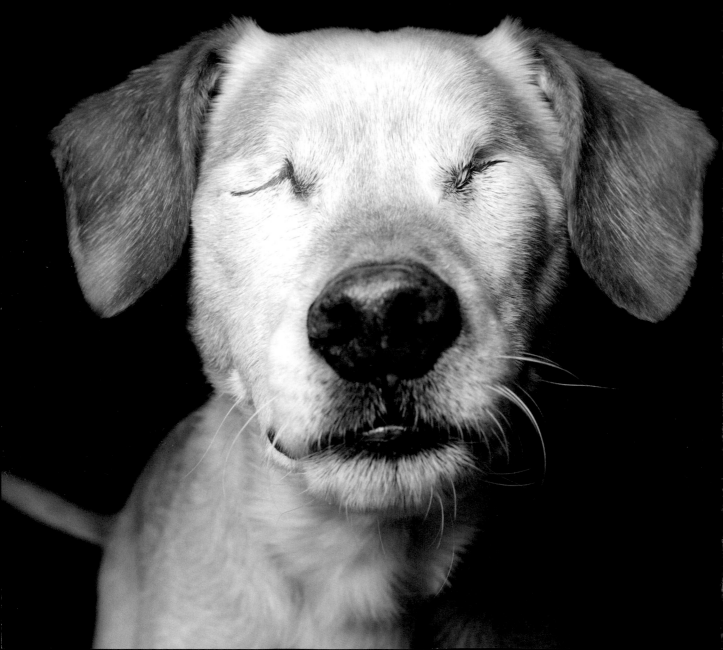

Scrappy

10 years old
Whippet x
Jack Russell

Human:
Jenny

Scrappy came into our lives as a stray in 2004 after he was hit by a car. Sadly he started going blind in 2008 as a result of retinal atrophy. He then had complications that resulted in one eye being removed in 2012 and the second in 2013.

Scrappy means the world to us. We think he's amazing because he's always so happy and it doesn't matter that he's blind; nothing's too difficult for Scrappy! You can't get away with going out the door without him as he always knows and insists on being in the way so he can come too. He gives the best cuddles and we can't imagine life without him.

Scrappy puts his complete trust in us and will give anything a go. He won a 'Hero's Award' for completing every obstacle in an obstacle dash simply by following our voice commands. Nothing stops him loving life and doing as much as a sighted dog.

People often think we have to keep everything the same and that Scrappy will be limited in what he can do, but nothing stops him. He loves being out and about and meeting new people and dogs. He goes on holiday with us, walks anywhere and everywhere, basically is included in our lives like any other dog would be. He is the best dog ever and we LOVE Scrappy.

Patch

**5 years old
Staffy cross**

**Human:
Janean**

I'd been looking to get a dog and was always checking the Dogs' Refuge Home of WA social media. I saw Patch on there and thought he was so cute with his distinctive colouring. The fact that he was missing a leg didn't bother me at all. I thought that made him even cuter.

Patch has brought so much love into our lives. He loves going on walks around the lake and for drives in the car and has his own fan club when we go out. He gets so much affection from people and totally loves every minute of it. He loves his cuddle time on the couch, chewing on his squeaky toys, and bed time.

Patch just loves going out. When we start getting ready to leave, he runs around the house, talking to us in his own special language to let us know when we're taking too long. He does the same thing every time, no matter what! Totally cracks us up.

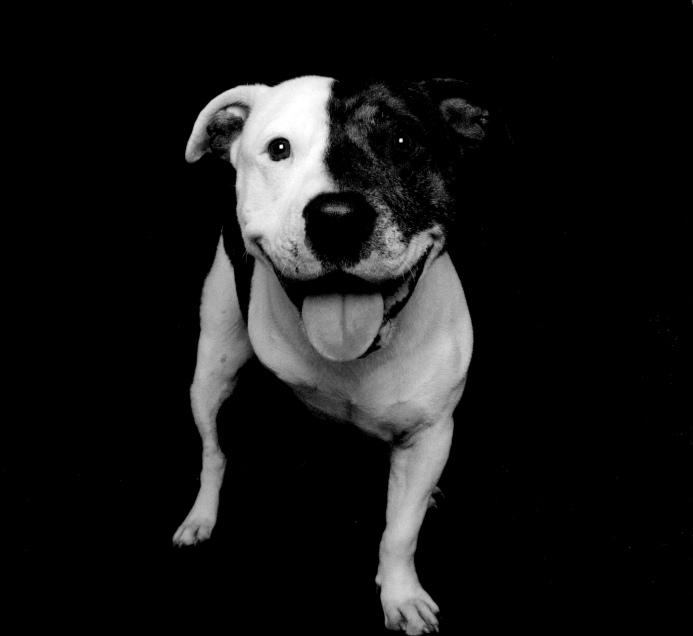

Milo

11 years old German shorthaired pointer

Human: Danae

Milo was born with a hernia and was the last puppy left in his litter (should've been a warning of things to come!) but he was just so adorable that there was no way I wasn't having him. He's basically allergic to everything but after years of desensitisation treatment he copes much better now. Milo first had joint problems when he was quite young and dislocated both elbows on separate occasions. He now has very bad arthritis and walks pretty bow-legged, but does his best. He has medication every day to keep him comfortable.

Milo is substantially deaf and quite blind, particularly in in his right eye, so often walks into things. His nose works very well, however! He definitely doesn't let any of his disabilities get him down. He still squeals the house down with excitement when he's getting ready to go for a walk.

I think a story that sums up Milo is this: For the first three years of his life, Milo spent every day with my previous German shorthaired pointer, Chewie. Chewie died unexpectedly and Milo was devastated. He spent a few days searching high and low for Chewie, then the realisation dawned on him: Chewie wasn't coming back. You could see the change in his demeanour after that; he was sad, but he worked it out and he accepted it. I believe Milo teaches us to love hard, change what you can for the better, accept what you can't and get on with it – make the most of every day of your life.

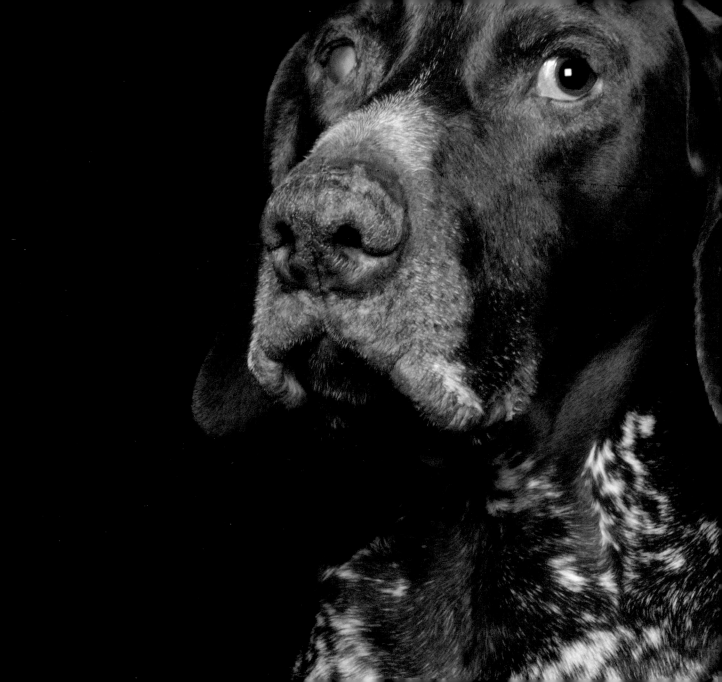

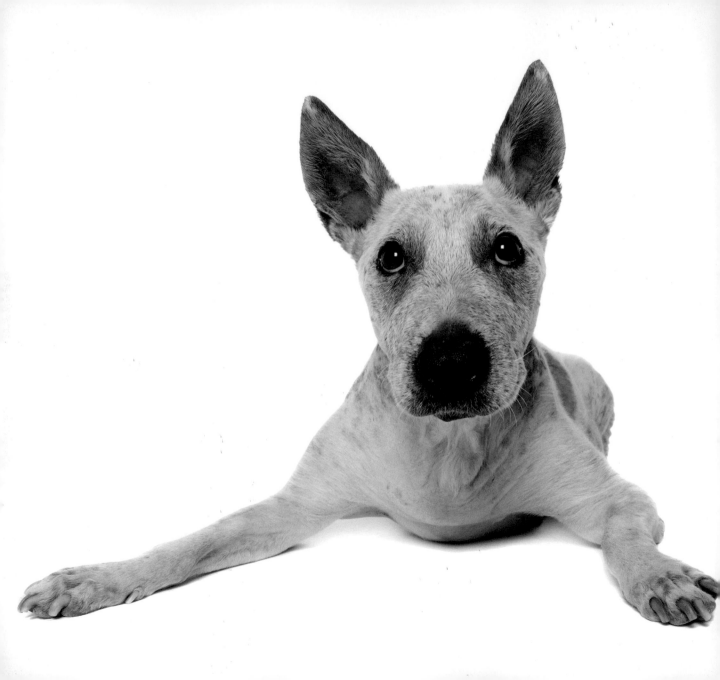

Jez

9 years old
Cattle dog cross

Human:
Martha

We adopted Jez from the Dogs' Refuge Home of WA in 2011. We never knew her full history as she had come from the pound. Soon after, she was diagnosed with Cushings disease (a chronic overproduction of cortisol) and lost most of her fur. The disease makes dogs appear overweight and lethargic.

Jez meant the world to us; she was a lovely-natured dog. She adored playing fetch, and balls never stood a chance. She loved people, new places and smells. She was like a child to us and had an endless supply of beds, coats, balls and love. Her tail never stopped wagging.

One night we came home to find that Jez had managed to reach some hot cross buns left on the kitchen counter. We knew this because there was a perfect paw print in one of the buns!

Keisha

**11 years old
Maltese cross**

**Human:
Janet**

Keisha developed IVDD (intervertebral disc disease), a spine condition which causes pain, nerve damage and even paralysis. It came on so suddenly. She was fine all day, running around and playing with my grandkids. At 6 pm she appeared to be limping and weak in her back legs so I took her to the vet. By midnight she was completely paralysed.

When Keisha got sick we were told to put her down if she couldn't toilet on her own within two weeks. We worked with her and helped her as much as we could. She still needs some help but her spirit is so strong and she's been so determined, we weren't going to give up on her while she was trying. We rested her for 12 weeks, then got her wheelchair. We were told to let her use it for 10-minute intervals to start, as she might not like or take to it. But the minute Keisha went into her chair she took off. She seemed to have a smile on her face and she was so confident. She even went to my car and tried jumping in as she used to. Her best friend, Reuben (overleaf), is also in a wheelchair.

Keisha's so loving and loyal and she's got me through some tough times.

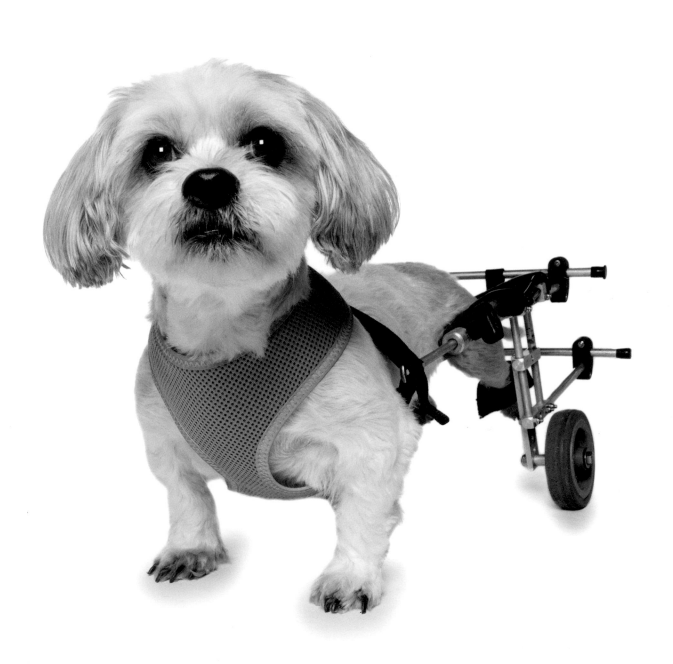

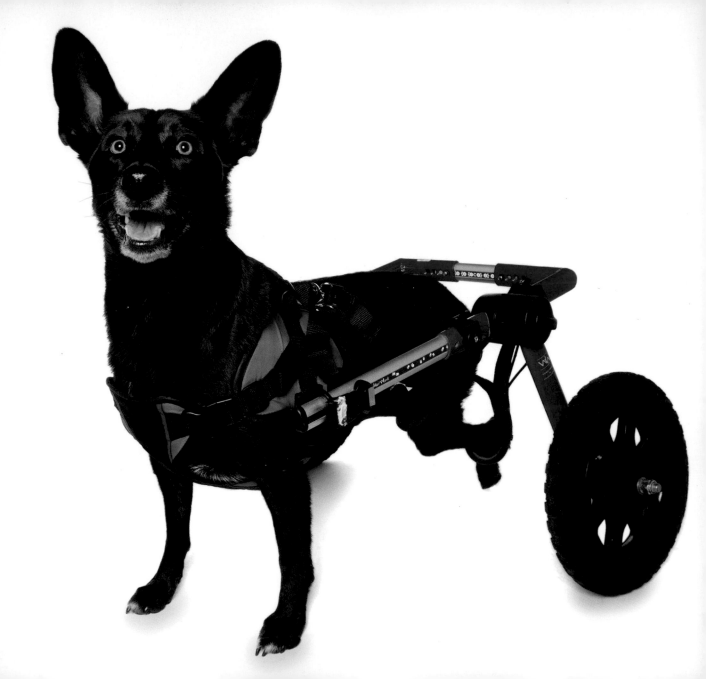

Rueben

7 years old
Kelpie x lab

Human:
Tanya

Being a working breed, Rueben has always been extremely active. He loves running, playing fetch and swimming. During his usual morning swim at the beach in December 2016 his back legs started collapsing and he was dragging them. I rushed him to the emergency vet and after many tests and a week in intensive care it was discovered he had a bulging disc that had ruptured and punctured his spinal cord. It was touch and go as to whether the paralysis would spread all the way up his spine to his brain but he's a fighter and miraculously it stopped just below his shoulders.

Rueben's eyes were still shining brightly and he was smiling; he was eating (he loves his food!) and was very excited to see visitors in hospital, so I knew he still had a full life to live. He'd already fought a life-threatening immune disorder at the age of two, so this certainly wasn't going to beat him. Once the paralysis set in there was no more pain and with a wheelchair and assistance to go to the toilet he is a fully abled dog.

Rueben has adapted so well. Of course it was very distressing and confusing for him in the early days, but once he got his wheels he was off and racing and never looked back! He enjoys all the activities he did before: swimming, fetch and camping. I don't think Rueben realises he's any different from other dogs or how he used to be.

Tyson

8 months old
Beagle cross

From:
RSPCA WA

Tyson came into the care of the RSPCA and had to have his leg amputated. A playful, sweet pooch, Tyson wasn't hindered at all by the loss of his leg. When he'd recovered, he was adopted into a loving home.

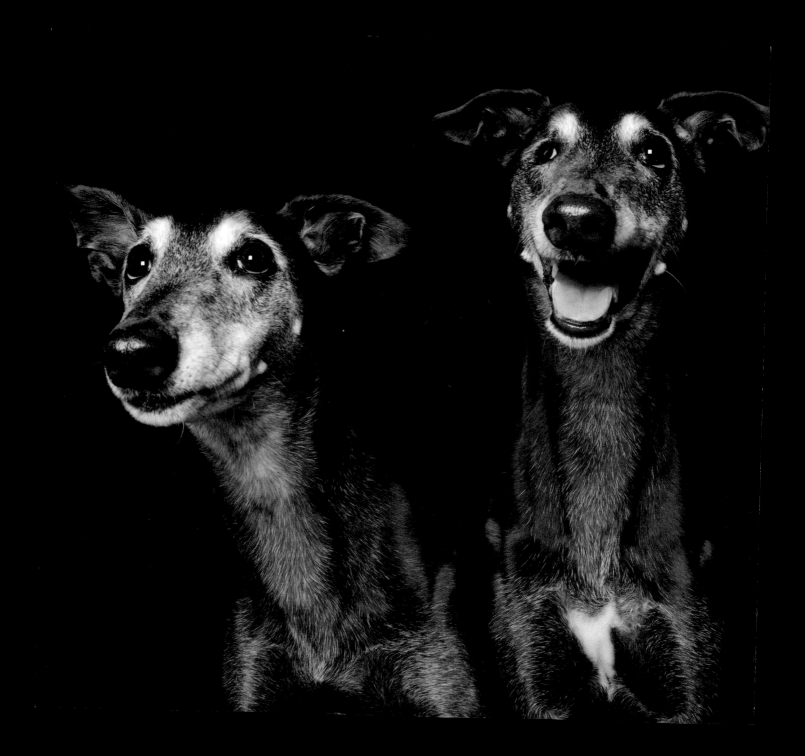

Sasha (with sister Bling)

8 years old
Greyhound

Human:
Linda

Sasha (right) was born with 'puppy cataracts' in her right eye, rendering her blind in that eye. She has a sweet, cuddly nature and has taught us a lot about overcoming difficulties.

Sasha is inseparable from her litter sister, Bling, who we refer to as Sasha's 'seeing eye dog'. They run together and eat together and Sasha puts Bling up to doing the 'cookie dance' for treats after dinner!

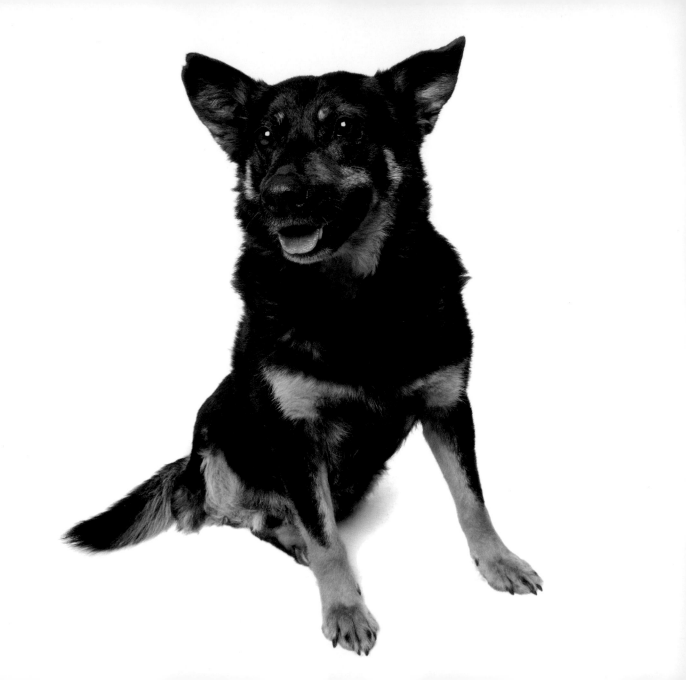

Lockie

**14 years old
Kelpie cross**

**Human:
Emma of
Brightside Farm
Sanctuary**

Lockie was surrendered to me when I worked at a vet clinic. He was a farm dog who'd been run over. He had a broken leg that couldn't be repaired and his then owner was going to put him down. Lockie fixed his eyes on me and would not break eye contact. He knew I was the one who would help him. The vet and I amputated his leg, I paid the bill and home we went. We walked out of the clinic and he ran across the carpark and leapt into the car as if we'd always been together.

Lockie had a huge heart and he was the kindest, most faithful and gentle friend to me for nine years. He was a happy, optimistic dog with a great sense of fun.

Bandit

10 years old
Bull terrier x
Jack Russell

Human:
Kathleen

Bandit came to us from the RSPCA WA. He was surrendered to a ranger and was about 2 when we adopted him. He had a large, permanent scar on his head, which we kept soft using cream. He really enjoyed his nightly head massage.

Bandit was bouncy, loving and fun. He had a great sense of humour and would steal roast chicken or my pyjamas to make me chase him. He loved rounding up waves at the beach and splashing in water when he had a bath.

Bandit trusted and loved everyone. He was a friend to all and loved a good belly rub. He would bounce up walls to catch beams of light and bound along the beach to chase waves, but his special skill was being able to do bombs into the pool on command. We would say, 'Readyyyyyyy?' and he would jump and splash into the pool. He loved it!

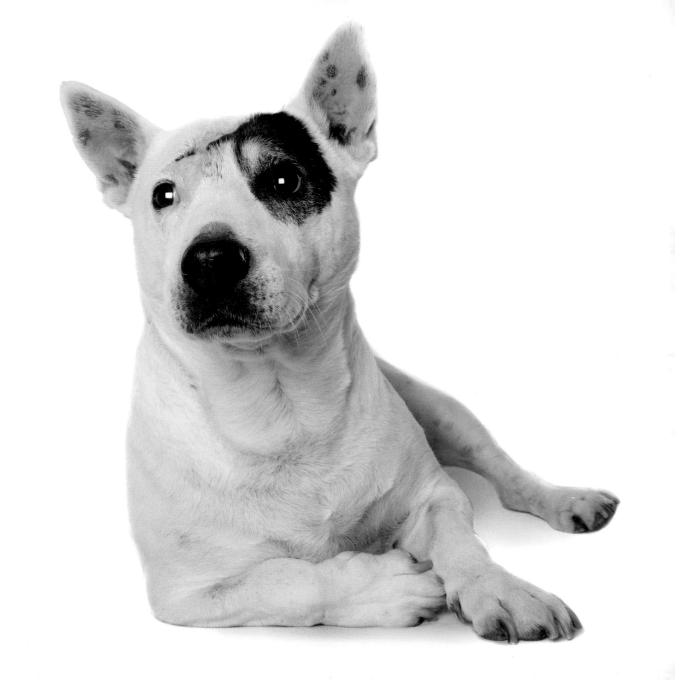

Stella

13 years old
Pug

Humans:
Karen & Eric

We adopted Stella along with Roly (a male pug) from a pug rescue organisation back in 2006 when we lived in Canberra. They were aged between 3 and 5 years at the time. Stella had already lost her eye by then, but we don't know what happened. These days she has very few teeth remaining, advanced arthritis and a tongue that dangles from her mouth no matter how she tries to haul it in!

Sadly, Roly recently passed away so Stella is even more special to us. Stella is a very sociable pug who likes to follow you around and find out what's going on, despite her old age. She loves to interact with our next-door neighbours' kids and used to race around and chase after them when she was much younger. She used to push Roly out of the dog bed to get the prime position. She's very bossy and likes to get her way, has selective hearing and will only do something if it suits her – a typical pug trait.

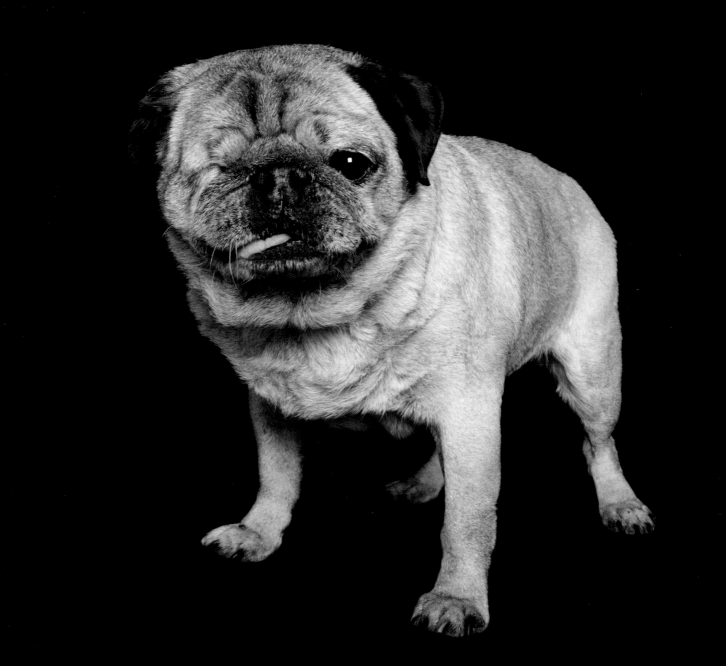

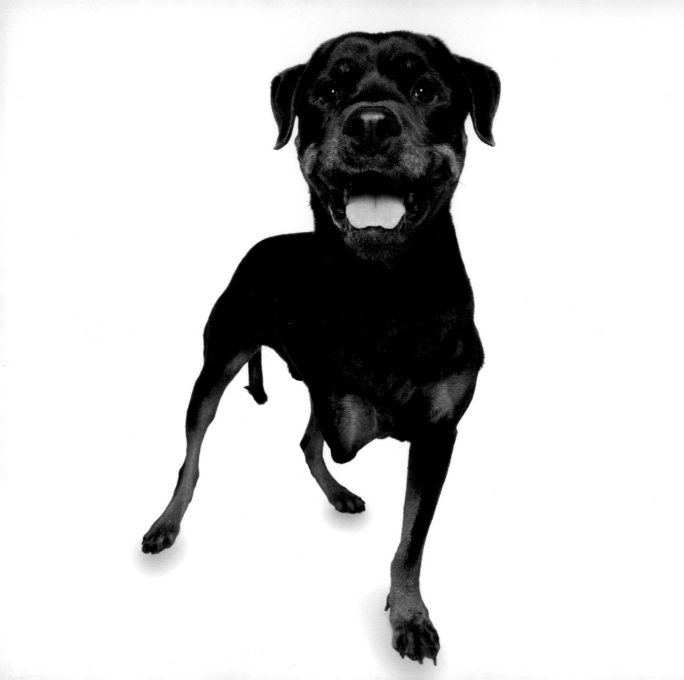

Zeus

8 years old
Rottweiler

Human:
Kylie

Zeus was diagnosed with an aggressive bone cancer in October 2016 and our fabulous vet advised amputation of Zeus's leg would be the best option to give us more time with him.

Zeus is definitely an affectionate dog and loves cuddles and attention from people and all other animals. He's a gentle soul – in a word, a sook.

The day we picked Zeus up from the vet after the amputation he came straight out to us and walked out to the car! He was just amazing, no issues about losing his leg – he just got on with it and has adapted really well. He still loves to run after his ball or herd up our chickens.

Louie

12 years old
Maltese terrier

Human:
Jess

I rescued Louie at 11 months old. A tiny 2.6kg purebred, he showed signs of physical abuse. I'll never forget getting him home that first night: when he heard a loud male voice he huddled in a corner shaking so much he looked as if he was having a fit. Years went by and he was always a little nervous, but grew into a funny, crazy little kid who loved his big fur brothers, a Staffy and a Great Dane cross.

One morning my Dane cross slipped on the wooden floor and fell on Louie, causing his eye to pop out of its socket. The vet managed to save it but his vision was mostly gone and his eye turned outwards slightly. After many months of healing he looked almost like his old self – then a cat managed to catch the same eye with its claw, piercing it deeply. Sadly the eye didn't respond to treatment and had to be removed.

To say I was devastated is an understatement. I felt I'd failed him after he'd already been through so much in his little life. The vet assured me he'd be better off and wouldn't even know it was gone and that it was me who had to accept it was for the best. And he was right. Animals have an amazing ability to adapt and are stronger than we realise. Four years later he's still as crazy as ever and shows no signs of slowing down.

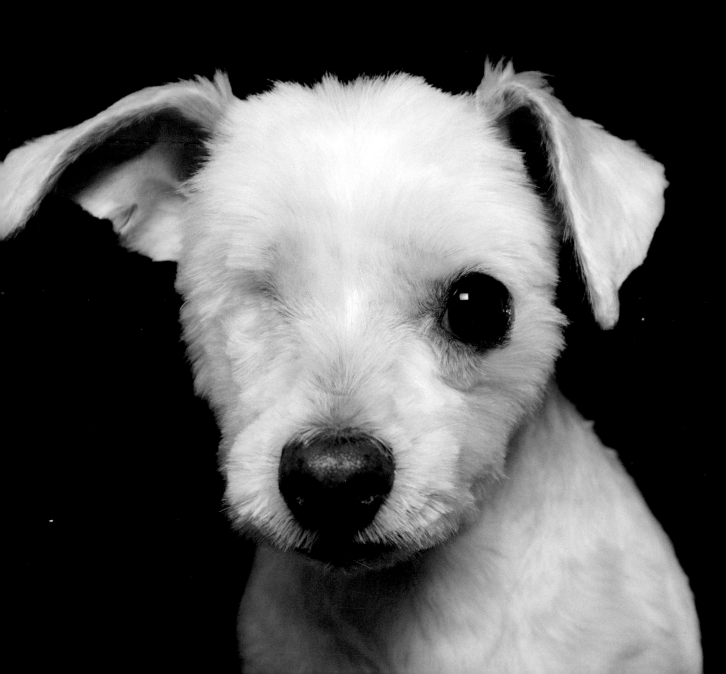

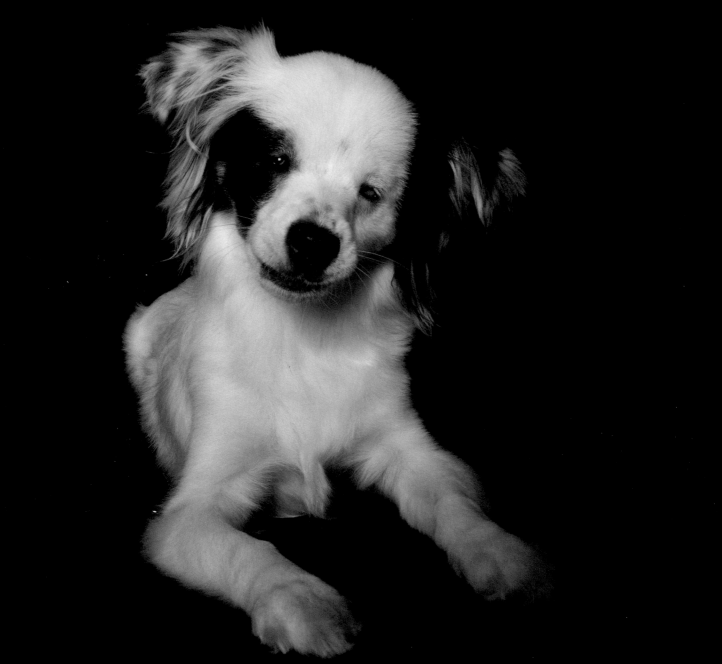

Angel

7 months old
Chihuahua cross

Human:
Cindy

Angel was adopted from Perth Chihuahua Rescue. When we first got Angel we thought she had hydrocephalus. But as she grew, her head became smaller – the opposite of hydrocephalus. My vet said she could have microphthalmia, a genetic problem in which dogs are born with small eyes. She is blind in one eye and has limited vision in the other.

Angel means the world to me! She proves that no matter what disability an animal has, they all deserve a chance in life. She helps people who feel down, as she just seems to brighten them up. Angel is kind to everyone. She likes to feel your face with her nose, then will demand pats.

Angel has an attitude. If she's naughty and you say, 'Off to your room', she'll stick her nose in the air and tail up and go into her room. Then a few minutes later she'll pop her head around the corner with her favourite bone toy in her mouth, and come over as if nothing's happened. It was inspirational to see Angel's best friend Primrose guide her around the house by walking by her side. The first thing Primrose did was show her the toy box – which was a big mistake, as Angel took every toy out. Now Angel has so much confidence she runs around the house like a mad dog and will run from the bedroom to the lounge room and back and slide into her bed. She'll keep doing it over and over again.

Barbara

14 years old
Cattle dog

Human:
Jenny

Barb came to our family as a pregnant 3-year-old foster dog from the RSPCA. She'd been badly abused by a male owner and had awful head wounds. Nerve damage leading to muscle wastage left her head misshapen.

Initially, Barbara was understandably nervous of men. I had to work with her to overcome issues like this and help her regain her confidence. This experience in part inspired to me study and gain my Certificate IV in Dog Behavioural Training. I was part of the Dog Behaviour Team for the RSPCA for years and Barbara was the demonstration dog for my training classes. She was a calm, loving and gentle dog – the sweetest creature to ever walk this earth, I think! We were very bonded and she was always with me. She was gentle with everyone – children, other dogs and even other animals. Once we found a litter of 3-week-old kittens and took them in, cared for them and eventually found them homes. Barb loved the kittens and cared for them like a mum. We kept one kitten, Clare, who adored Barb for the rest of Barb's life.

Her calmness and gentleness was always reassuring to others.
She meant so much to all of us.

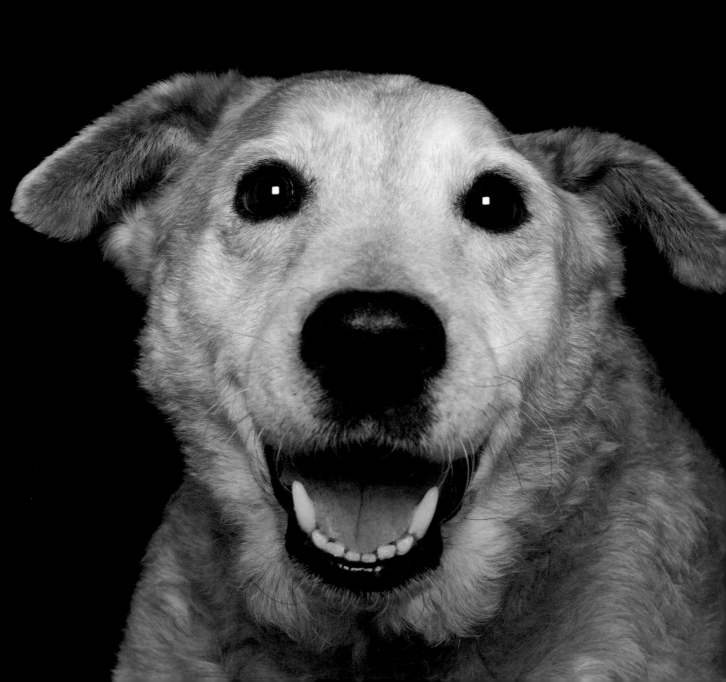

Rupert

12 years old
Red heeler cross

Human:
Laura

Rupert somehow damaged his eye. He was taken to the vet right away for treatment and then to an ophthalmologist, but his injury didn't resolve. Ten days later he underwent surgery to have it removed. He was a very brave patient and given he was an aged dog he made an amazing recovery, although his depth perception made playing tug of war very funny.

Rupert was in all aspects my best friend. He made me smile every day. He was funny, kind, very clever. To me, he was perfect in every way. Whenever I think of him, I still smile.

In our younger days Rupert and I went everywhere together; he even had his own bed in the back of the ute. While the outside of the car was cleaned often, Roo's bed I tended to leave alone. That is, until I found he had been taking things when on our visits. At one stage I removed various toys that had belonged to his friends – sticks, bones and even shoes. We were both a bit sheepish when we returned them, but it still makes me laugh.

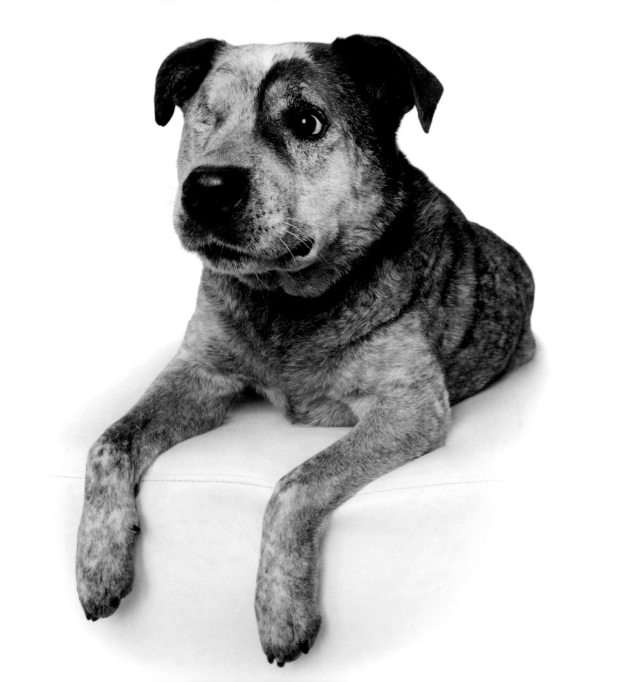

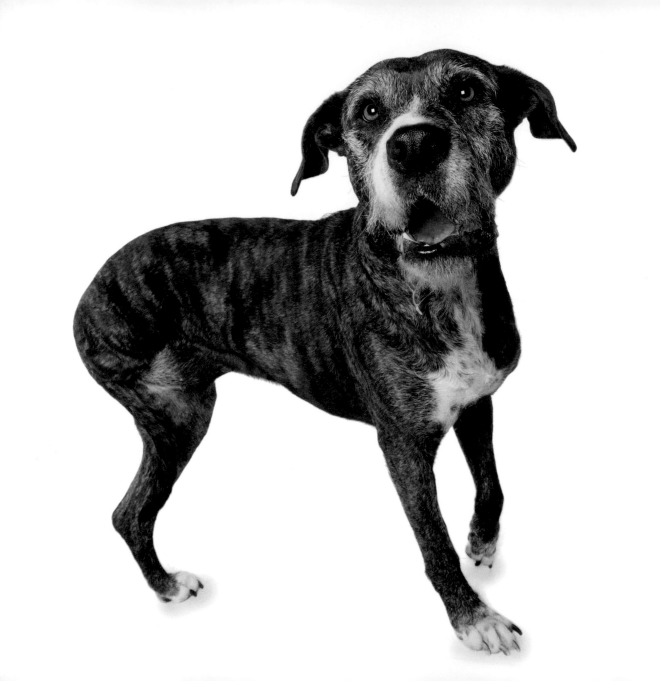

Bella

9 years old
Mastiff x
wolfhound

Human:
Lynnie

Bella was diagnosed with osteosarcoma (bone cancer). The vet showed us the massive tumour on the X-rays and I can't imagine the pain she was in. I had to make the decision to either euthanise her or amputate the leg, so I took her home that night to think about what to do. It was a very emotional decision, but we decided to let Bella guide us and the next morning when she got up, ran around the house, stole the cat food, played with her toys and smiled, we knew she still wanted to be here.

We had a few horrible days after the op, and I felt very low, questioning if I'd done the right thing. But then one day she was back to herself again. She's now running around the park faster than before she lost the leg. She does everything she could do before she was a tri-paw: jumping into the car, looking over the fence, stealing food from the kitchen bench and of course stealing the cat's food. It's amazing how much *joie de vivre* she has.

Ironically, I originally took Bella on after my last beloved dog died of the same cancer. I decided to adopt a shelter dog to help me with my grief and to give a dog a home. Bella hasn't always been the easiest of dogs and I've had to work with her a lot to help her with her nervousness and reactivity. But through this I've learnt a lot about myself and become much closer to her.

Hugo

5 years old
Dogue de Bordeaux
(French mastiff)

Human:
Julie

Hugo was one of approximately 55 dogs rescued by Brightside Farm Sanctuary from a backyard breeder. Hugo had severe untreated mange, very little hair and extensive infections. He also had a problem with his heart – cardiomyopathy, basically an enlarged heart that over time worsened, and that's what I eventually lost him to.

Hugo was amazing and every day he inspired me. I first met him late one night when Emma from the sanctuary brought him back with other dogs rescued from the breeder. She had asked if I would foster him as his mange was so severe. I wasn't quite sure what to expect but meeting him put me into sensory overload. The sight of this massive dog with the most terrible skin I had ever seen, and the smell of mange and infected skin. But then I looked into his eyes and it was like looking into his soul. What he'd been through I hate to think, but I took Hugo home and he came straight into my home as if he had always been there. He shared his life with cats, dogs, roosters, horses, cows, goats, geese, ducks and a roving peacock and never ruffled a feather or a hair. He needed ongoing treatment, weekly baths, vet visits and medication for his heart, but he never once complained or took his new life for granted. His loving, loyal and gentle nature shone through. He was the dog love of my life. Sadly I only had him for two years but he gave me so much in that time.

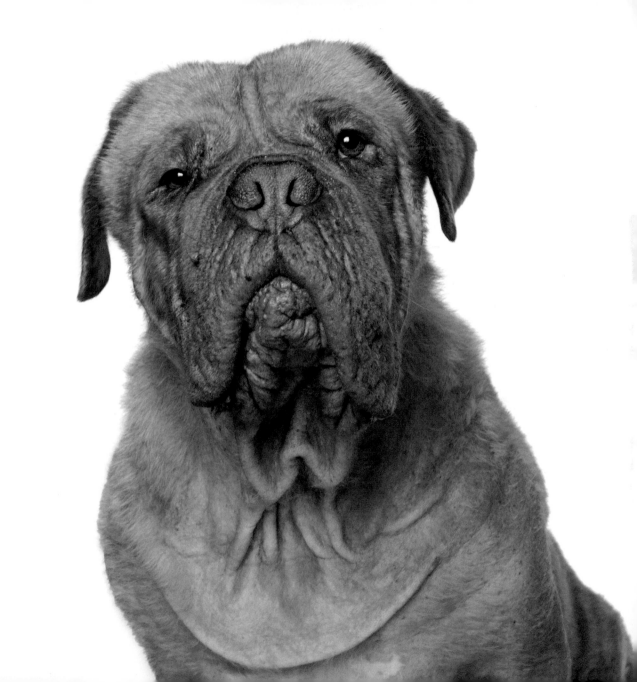

Savannah

4 years old
Rottweiler

Human:
Sarah

Savannah was only 3 when she started to limp slightly but we thought she'd just overdone it in the park. We were devastated to discover that she had bone cancer and the most aggressive kind – an osteosarcoma.

We were so fortunate to find an incredible vet who was willing to trial a screw-in metal prosthetic leg for Savannah and we were amazed to see how well she adapted to it – she was able to swim and dig holes in the beach with it in no time. Savannah absolutely loved swimming in our pool and we thought her metal leg would stop her being able to get in and out – but no! We couldn't keep her out of the pool and her surgery seemed to have no impact on her swimming whatsoever – she was incredible.

Sadly, about a year later, the cancer returned in her back and we lost her just after her fifth birthday.

Savannah meant the world to us. She was such a happy girl and so brave, despite having to endure so much.

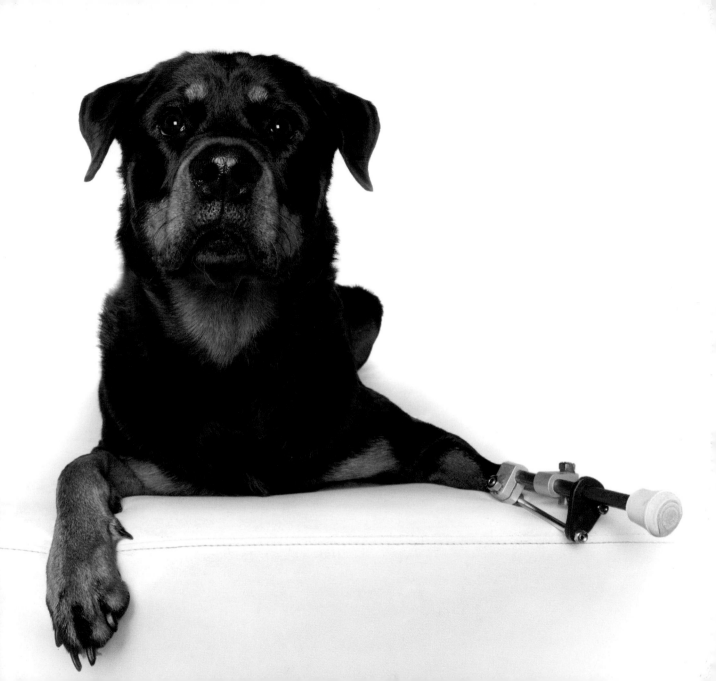

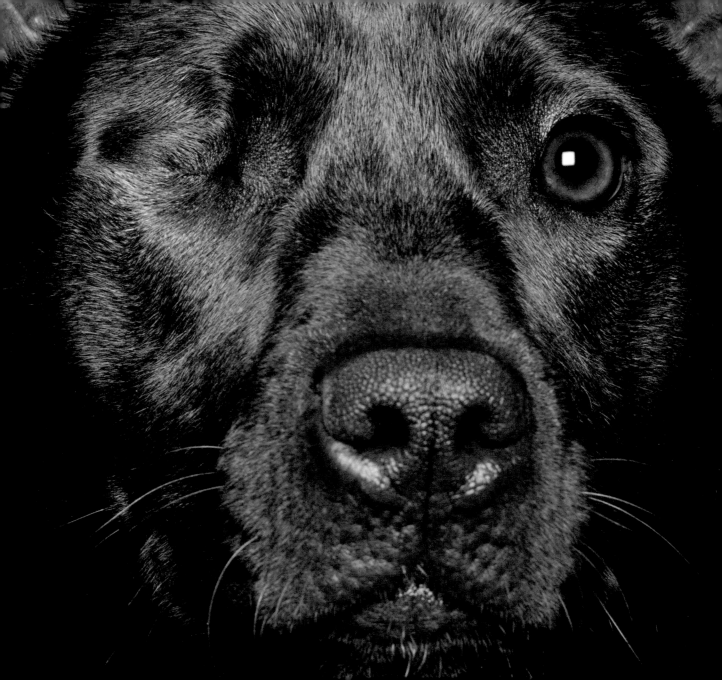

Acknowledgments

Every book is a team effort and for me this one began eight years ago, back when I first started photographing animals I classified as 'perfectly imperfect'. The first thanks must go to the wonderful, kind humans who see into a dog's soul and love unconditionally. These people realise that their pet gives the same love as any other, and needs the same love as any other. That they have value and their life matters. Yes, these humans have special animals, but they are special people too.

Thanks to my patient publisher, Katie Stackhouse from ABC Books (herself a Perfect Imperfection dog Mum – to Daisy the deaf cavalier), for her guidance along the way and for creating a book which does justice to its canine stars. Thanks to Helen Littleton from HarperCollins for assisting me in the early stages, and for making my day with images of her sweet greyhound, Silver, who was usually in a reclined pose.

↓

Acknowledgments

↓

To my trusted friend Andrea McNamara, for directing me towards the door of ABC Books. Your friendship is valued and your candour appreciated. Always.

Thanks to my nearest and dearest, my family – human and furry. Debora, Pip, Pixel and Macy, you bring joy to my life and you have been on this journey since the beginning. I couldn't do it without you all.

And lastly, I'm sending heartfelt wishes out to every dog who is perceived as different, whether through birth, accident or illness. You deserve love. You deserve kindness. And you deserve to live.

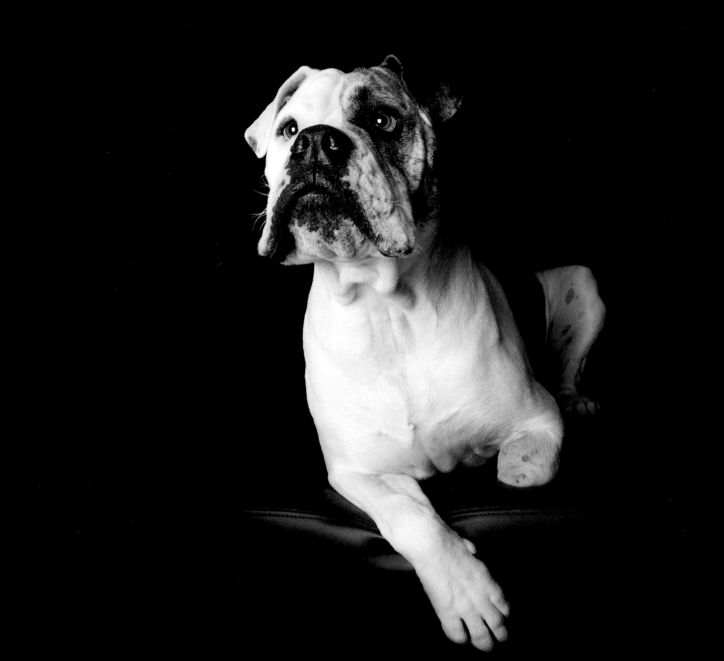

About Alex Cearns

UK magazine *Dogs Today* called Perth-based photographer Alex Cearns 'one of the greatest dog photographers in the world'. Alex is the creative director of Houndstooth Studio and specialises in capturing portraits that convey the intrinsic character of her animal subjects.

Alex photographs over 800 beloved pet dogs each year. She also works with around 40 Australian and international animal charities and conservation organisations, including Guide Dogs WA, 'Free the Bears', Dogs' Refuge Home, and the Bali Animal Welfare Association. She has received more than 200 awards for photography, business and philanthropy.

Inspired by the joy of working with animals, Alex's philanthropy and passionate advocacy for animal rescue has earned her high regard among Australia's animal lovers and a strong following on social media. She regularly appears in print media and on radio and television.

A self-confessed crazy dog lady, Alex loves to hug all animals, especially her rescue dogs Pip the kelpie greyhound mix, Pixel the greyhound and moggy Macy. Follow Alex on www.facebook.com/HoundstoothStudio

see your pet
in a new light.

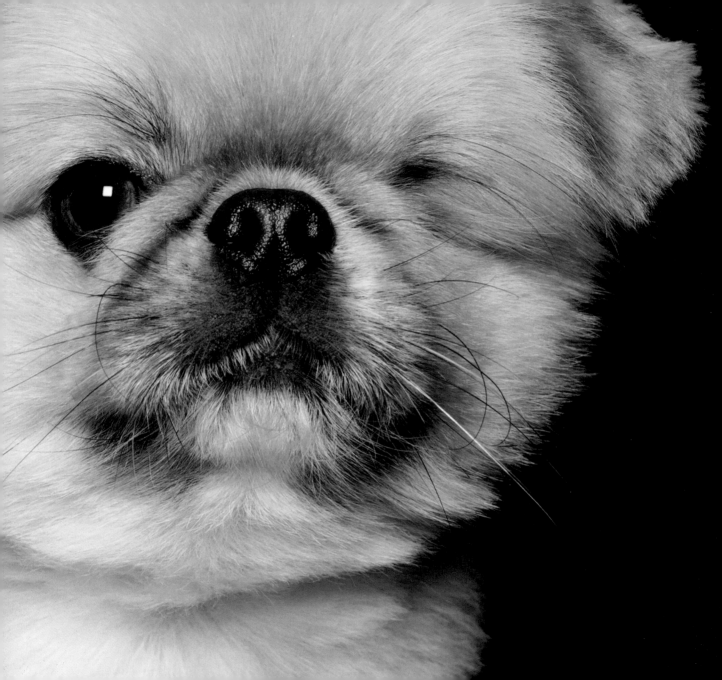

Australian Animal Cancer Foundation

A percentage of royalties from each book sold will be donated to the charity organisation Australian Animal Cancer Foundation. It's a shocking statistic that one in every three domestic dogs will be diagnosed with cancer. The Australian Animal Cancer Foundation funds valuable equipment and research essential to the treatment and study of cancer in companion animals. Their research is interchangeable with human cancer research – so perhaps one day dog cancer research could lead to cures for human cancers as well.

With every purchase of this book animal lovers are making a difference by contributing to a good cause, one that relates to the many beautiful dogs in *Perfect Imperfection* who have lost a limb or had an eye removed because of cancer.

For more information on the Australian Animal Cancer Foundation visit https://animalcancer.com.au

The Models

Alluna p88, p132

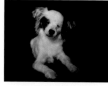

Angel p120

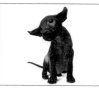

Aryah p58

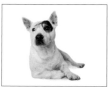

Bali Pip p14

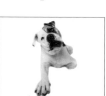

Bandit p113

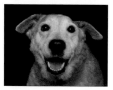

Barbara p123

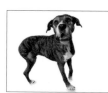

Bella p126

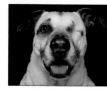

Bender p76

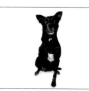

Boris p78

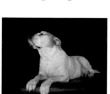

Brutus p90, p135

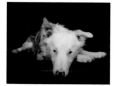

Buzz p26

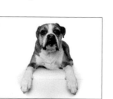

Cass p20

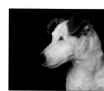

Dotty p4, p29

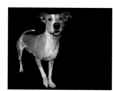

Frank p40

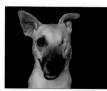

Frankie p84

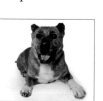

Fudge p31

Geri p57

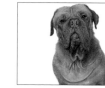

Hannah p8, p73

Hugo p129

Jack p19

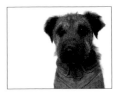 **Jakk** p7, p70

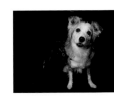 **Jessie** p33

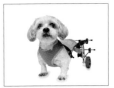 **Jez** p100

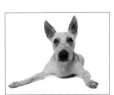 **Keisha** p2, p103

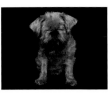 **Lady Bug** p10, p54, p144

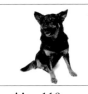 **Lockie** p110

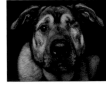 **Locki** p42

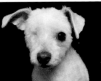 **Louie** p119

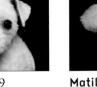 **Matilda** p25

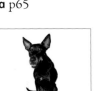 **Mia** p65

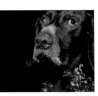 **Milo** p99

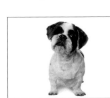 **Misha** p34

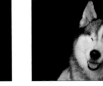 **Moe** p17

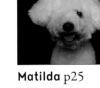 **Mya** p61

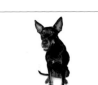 **Odin** p50

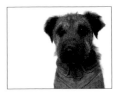 **Oompah** p83

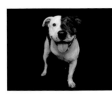 **Patch** p97

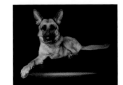 **Penelope** p37

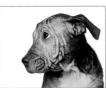 **Perse** p48

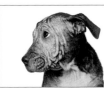 **Polly** p39

141

The Models

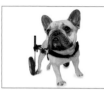 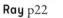 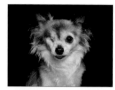 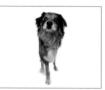

Raul p13 **Ray** p22 **Reuben** p2, p104 **Romeo** p47 **Rowdy** p53

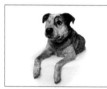 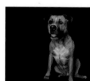 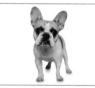 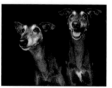 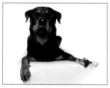

Rupert p125 **Sam** p75 **Sarai** p67 **Sasha + Bling** p108 **Savannah** p131

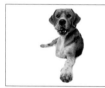 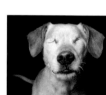 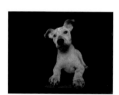 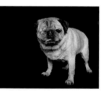

Scooter p68 **Scrappy** p94 **Shazza** p80 **Spike** p87 **Stella** p115

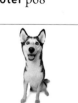 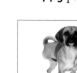 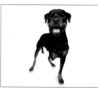 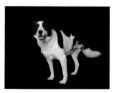

Tiki p62 **Tyson** p107 **Vegemite** p93, p138 **Zeus** p116 **Zulu** p45

The ABC 'Wave' device is a trademark of the
Australian Broadcasting Corporation and is used
under licence by HarperCollins*Publishers* Australia.

First published in 2018
by HarperCollins*Publishers* Australia Pty Ltd
ABN 36 009 913 517
harpercollins.com.au

HarperCollins*Publishers*
Level 13, 201 Elizabeth Street, Sydney, NSW 2000, Australia
Unit D1, 63 Apollo Drive, Rosedale, Auckland 0632, New Zealand
A 53, Sector 57, Noida, UP, India
1 London Bridge Street, London, SE1 9GF, United Kingdom
2 Bloor Street East, 20th floor, Toronto, Ontario M4W 1A8, Canada
195 Broadway, New York, NY 10007, USA

A catalogue record for this book is available from the National Library of Australia

Cover design by Darren Holt, HarperCollins Design Studio
Internals design by Darren Holt and Jane Waterhouse
Colour reproduction by Graphic Print Group, Adelaide
Printed and bound in China by RR Donnelley

The papers used by HarperCollins in the manufacture of this book are a natural, recyclable product made
from wood grown in sustainable plantation forests. The fibre source and manufacturing processes meet
recognised international environmental standards, and carry certification.

'Animals with "disabilities"
don't dwell on them.

They adapt.

They survive.

They get as much out of life as they can.

I take great care to reveal their beauty,
inviting the viewer to look beyond their
afflictions to see their sentient souls.
My hope is for an appreciation that
they are perfect in their imperfection.
As loveable and worthy as any other.'

Alex Cearns